**D0635167**

## FICTION RESERVE STOCK LL60

*Daniel Arsand*

# *The Land of Darkness*

## Translated by Christine Donougher
## with an introduction by Kate Britten

Dedalus

*Dedalus would like to thank The Arts Council of England and The Burgess*
*Programme of The French Ministry of Foreign Affairs in Paris for their*
*assistance in producing this book.*

Published in the UK by Dedalus Ltd, Langford Lodge, St Judith's Lane, Sawtry,
Cambs, PE28 5XE
email: DedalusLimited@compuserve.com

ISBN 1 873982 99 2

Dedalus is distributed in the United States by SCB Distributors, 15608 South New
Century Drive, Gardena, California 90248
email: info@scbdistributors.com   web site:www.scbdistributors.com

Dedalus is distributed in Australia & New Zealand by Peribo Pty Ltd, 58 Beaumont
Road, Mount Kuring-gai N.S.W. 2080
email: peribo@bigpond.com

Dedalus is distributed in Canada by Marginal Distribution, Unit 102, 277 George
Street North, Peterborough, Ontario, KJ9 3G9
email: marginal@marginalbook.com   web site: www.marginal.com

Dedalus is distributed in Italy by Apeiron Editoria & Distribuzione,
Localita Pantano, 00060 Sant'Oreste (Roma)
email: grt@apeironbookservice.com

*First published in France in 1998*
*First published by Dedalus in 2001*
*La province des ténèbres copyright* © *Daniel Arsand 1998*
*Translation copyright* © *Christine Donougher 2001*

The right of Daniel Arsand to be identified as the author and Christine Donougher
to be identified as the translator of this work has been asserted by them in accordance
with the Copyright, Designs and Patents Act, 1988.

Typeset by RefineCatch Ltd
Printed in Finland by WS Bookwell

institut français

## French Literature from Dedalus

French Language Literature in translation is an important part of Dedalus's list, with French being the language *par excellence* of literary fantasy.

**The Land of Darkness** – Daniel Arsand £8.99
**Séraphita** – Balzac £6.99
**The Quest of the Absolute** – Balzac £6.99
**The Experience of the Night** – Marcel Béalu £8.99
**Episodes of Vathek** – Beckford £6.99
**The Devil in Love** – Jacques Cazotte £5.99
**Les Diaboliques** – Barbey D'Aurevilly £7.99
**The Man in Flames (L'homme encendie)** – Serge Filippini £10.99
**Spirite (and Coffee Pot)** – Théophile Gautier £6.99
**Angels of Perversity** – Remy de Gourmont £6.99
**The Book of Nights** – Sylvie Germain £8.99
**The Book of Tobias** – Sylvie Germain £7.99
**Night of Amber** – Sylvie Germain £8.99
**Days of Anger** – Sylvie Germain £8.99
**The Medusa Child** – Sylvie Germain £8.99
**The Weeping Woman** – Sylvie Germain £6.99
**Infinite Possibilities** – Sylvie Germain £8.99
**Là-Bas** – J. K. Huysmans £7.99
**En Route** – J. K. Huysmans £7.99
**The Cathedral** – J. K. Huysmans £7.99
**The Oblate of St Benedict** – J. K. Huysmans £7.99
**The Mystery of the Yellow Room** – Gaston Leroux £7.99
**The Perfume of the Lady in Black** – Gaston Leroux £8.99
**Monsieur de Phocas** – Jean Lorrain £8.99

**The Woman and the Puppet (La femme et le pantin)** – Pierre Louÿs £6.99

**Portrait of an Englishman in his Chateau** – Pieyre de Mandiargues £7.99

**Abbé Jules** – Octave Mirbeau £8.99

**Le Calvaire** – Octave Mirbeau £7.99

**The Diary of a Chambermaid** – Octave Mirbeau £7.99

**Sébastien Roch** – Octave Mirbeau £9.99

**Torture Garden** – Octave Mirbeau £7.99

**Smarra & Trilby** – Charles Nodier £6.99

**Manon Lescaut** – Abbé Prévost £7.99

**Tales from the Saragossa Manuscript** – Jan Potocki £5.99

**Monsieur Venus** – Rachilde £6.99

**The Marquise de Sade** – Rachilde £8.99

**Enigma** – Rezvani £8.99

**The Wandering Jew** – Eugene Sue £10.99

**Micromegas** – Voltaire £4.95

*Anthologies featuring French Literature in translation:*

**The Dedalus Book of French Horror: the 19c** – ed T. Hale £9.99

**The Dedalus Book of Decadence** – ed Brian Stableford £7.99

**The Second Dedalus Book of Decadence** – ed Brian Stableford £8.99

**The Dedalus Book of Surrealism** – ed Michael Richardson £9.99

**Myth of the World: Surrealism 2** – ed Michael Richardson £9.99

**The Dedalus Book of Medieval Literature** – ed Brian Murdoch £9.99

**The Dedalus Book of Sexual Ambiguity** – ed Emma Wilson £8.99

**The Decadent Cookbook** – Medlar Lucan & Durian Gray £9.99

**The Decadent Gardener** – Medlar Lucan & Durian Gray £9.99

## THE TRANSLATOR

Christine Donougher was born in England in 1954. She read English and French at Cambridge and after a career in publishing is now a freelance translator and editor.

Her many translations from French and Italian include four novels by Sylvie Germain, *Enigma* by Rezvani, *The Experience of the Night* by Marcel Béalu, *Le Calvaire* by Octave Mirbeau and *Tales from the Saragossa Manuscript* by Jan Potocki.

Christine Donougher's translation of *The Book of Nights* by Sylvie Germain won the T. L. S. Scott Moncrieff Prize for the best translation of a Twentieth Century French Novel during 1992.

To Nicole, Evy and Kathy

To Antonia

To Pascale G.

# INTRODUCTION

The course of history has been punctuated by the actions of those who have sought to conquer the world. The man most successful in this aim was, perhaps, the fearsome Mongol leader, Genghis Kahn who, by his death in 1227, had conquered most of Central and East Asia, from Korea to the Caspian Sea. His successors extended the Mongol Empire into the Middle East and Eastern Europe, and by 1280 Genghis' grandson, Kubilai, ruled an empire that included virtually all of present-day China and Mongolia and reached as far west as the Danube.

It was during this period that European merchants and missionaries began to travel in caravans along the Silk Route – made safe by Mongol rule – to China. The overland journey took several years and extremes of climate and terrain meant that it was not without risk. It is one such journey that provides the backdrop for *The Land of Darkness*.

Daniel Arsand was born on 9th of July 1950 in Avignon in the south of France. After spending his childhood and adolescence in Roanne, near Lyon, he moved to Paris and became a bookseller at the Fontaine-Bourse bookshop. In 1979 Arsand established the publishing house, les Editions de la Sphere, which published George Sand's *Consuelo* and John McGahern's *L'Obscur*.

After 17 years in publishing, Arsand turned his hand to writing. Originally intending to write a contemporary novel, Arsand instead found himself stirred by books on ancient Mongol history. His love of nature, of large open spaces and his fascination with the lives of Genghis and Kubilai Kahn inspired Arsand to set his first novel, which became *The Land of Darkness*, in thirteenth century Asia.

Arsand spent over a year reading the history, legends and novels of this period and, by the time he started to write, he felt his imagination to be furnished with the lands and civilisations depicted in his novel.

The son of an Armenian Turk, Arsand was also keen to write a book which began in Turkey. Thus the opening chapters of *The Land of Darkness* are set in Lesser Armenia, which is in the south of present-day Turkey.

Details of the route taken by Arsand's characters, from Lesser Armenia to the Mongol capital in Peking, seem to have been derived from the documented accounts of thirteenth century travellers. There are remarkable parallels to be drawn between Arsand's character, Montefoshi and the Venetian merchant and traveller, Nicolo Polo, lesser known father of Marco. In much the same way as Montefoshi, Nicolo made two journeys to Peking. He returned from the first, again like Montefoshi, with letters from Kubilai requesting he return with learned men and artists to instruct his people in Christianity. In the early 1270s Nicolo set off once again for China to execute the Kahn's mission, taking with him his son Marco. Their route, through Turkey, Iran, Afghanistan, across the Pamirs and into northern China, is similar to that taken by Arsand's characters. They too were accompanied by two monks who soon lost heart and turned back.

In Vartan, the Friar and illuminator, we find echoes of Giovanni Di Monte Corvino, a Franciscan missionary, who set out for Peking in the same year as Arsand's characters. He arrived in 1294 and was well-received by the Khan. Unlike Vartan, he appears to have had some success in taking the True Faith to the East. He became archbishop of Peking in 1307 and some accounts suggest that he converted the Great Khan to Christianity.

The fact that Arsand bases his fiction in a geographical and historical reality makes it all the more compelling. Although the characters and the events that befall them are Arsand's

own creations, the places they visit and the conditions they encounter are real.

*The Land of Darkness* is not merely an account of a journey to the East. Rather, it is an exploration of the darker side of human nature. Each of the main characters represents an aspect of contemporary civilisation; the merchant (Montefoshi), the Friar (Vartan), the thief (Hovsep) and the leader (Jebe). These characters, initially united by their shared eagerness to reach Peking, are brought into conflict by their individual self-seeking desires. In the claustrophobic atmosphere of the caravan, this conflict gives rise to greed, jealousy, lust, fear and hatred, expressed in their most raw forms.

Arsand presents us with an array of tormented and unsavoury characters, as intriguing as they are repulsive. *The Land of Darkness* is a dark, disturbing and moving tale of how man's humanity can be so easily consumed by his baser passions.

# MONTEFOSCHI'S STORY

# I

Hethum II, King of Lesser Armenia and a Franciscan friar, was constantly torn between the monastery and the throne. Within the space of twelve years he would twice abdicate and three times take up the sceptre. And while he reigned, his face was turned towards the cross.

One evening in the year 1289, he prayed to God that the political alliance he had established with Rome should long continue. Some of his close advisers, a great many of the aristocracy and his entire people condemned his pro-Latin sympathies. The Armenian patriots, nurtured in the bosom of the Gregorian Church, were harshly critical of this monarch who bowed to a pope. Treason lurked in the palace chambers, in the towns and countryside, as well as on the borders of Hethum's realm: the Franks dreamed of gaining control of a state whose ports were flourishing; the Mongols of Persia, former allies, who were about to convert to Islam, would surely not fail to become sworn enemies. Weary, then, of conspiracies and wars, Hethum II knelt, his hands joined in prayer. He strove to express words of adoration, to no avail. The drone of distant chanting and the sound of voices from the kitchens distracted him. Hethum then crossed himself and stood up. Night was encroaching on the sky and a February mildness still lingered. As the room filled with shadows, the king's thin bearded face grew indistinct. Yet anyone able to see him would have caught a smile on his lips, for Hethum was thinking about a Venetian merchant, Vicente Montefoschi, and it restored his equanimity to think about such a man. At dawn the next day Vicente Montefoschi was to conduct one of Lesser Armenia's most famous painters to Peking, where Kubilai, khan of all the khans, had made his capital. Consequently, the king began to feel hopeful: in a few

months' time a monk skilled in the art of illumination would paint a picture, before the Emperor of the Mongols, of Christ in His glory, and bring the true faith to the remotest corner of the world. And Hethum would be responsible for this. His confidence restored, his anxiety quelled, the king of Lesser Armenia returned to kneel at the foot of a crucifix to entreat his God to keep him awake and joyful until daybreak.

# II

In a room in the fortress of Sis, palace of Hethum II, Vicente Montefoschi was enjoying a rest and resigning himself to insomnia. Tomorrow he was to embark on his second journey to China. Glory beckoned, since a pope and a king had named him as their ambassador to Kubilai. And yet his family was not related to those lords of Venetian commerce the Sanudo, the Querini, or the Morosini. The son of an ordinary trader whose wealth and fame could not rival theirs, he was nevertheless more ambitious than his father and more cunning than Venice's thieves or bankers.

As a youth, he became acquainted with the sea, with its storms and pirates, and stabbed a man to death to save his own life. At twenty, he was already the sure judge of a slave's muscles, the quality of a piece of cloth, and the soundness of a gold coin. A decade later it was being murmured that he had the potential to supplant the Sanudo, or the Querini. Indeed, he was successful in everything he did; his domain extended from Greece to the Black Sea.

But one day when strolling among the warehouses at his home in Sudak, in the Crimea, he had a revelation: no merchant to his knowledge had ever won eternal fame. As it had been his hope since childhood that his name would live on through the ages, this realization came as a blow. Above all else a man of action, Montefoschi wasted little time in dwelling on the obscurity to which those of his profession were doomed. Instead he examined the past to see who had left a lasting impression on it. Nearly all were princes, philosophers, saints or military leaders. As he was not of royal blood, nor in the least inclined to self-mortification, and impervious to the theories of Aristotle or Plato, the military profession seeme the best option for creating a destiny that would not

15

forgotten. This idea so excited him that he overlooked the fact that waging war requires experience and time has to be served in the ranks before attaining promotion to higher office. His imagination fired, he dreamed of victories in the coming years and lost that appreciation of realities which had enabled him to amass his wealth. He then shared with some of his friends his plans for conquest, and with his talk even beguiled those, like him, who hungered after exotic lands. His tall stature and gift of eloquence convinced them that sooner or later he would be seated at Kubilai's right hand, or that he would lay waste to plains and cities, and be immortalized by his exploits. They vowed to follow him to those regions inhabited, he said, by killer birds and stony-hearted human beings. To avoid the rigours of winter, he decided that the expedition would begin in spring.

One March morning he set out at the head of some thirty men, entrusting his warehouses and ships to the supervision of an agent.

With each successive stage of their journey, the Venetian revealed his true personality: the man was forged out of pride and cruelty. He was cuttingly sarcastic if his companions' courage failed them, and exposed them to the muleteers' derision. Many of them, grown weary of his gibes and scorn, turned back to Byzantium, Sudak, or Ayas. Their desertion seemed to have hardly any affect on him. He travelled the routes of the East, confident of his future, as if a world of marvels awaited him, in which he would have his place. And the gods of every country he passed through surely did protect him, for he reached Peking without experiencing the fear or the hazards familiar to every wayfarer of those times.

Kubilai did not grant him an audience until a month after his arrival. Montefoschi won over his host by praising the postal system that crisscrossed the Mongol Empire and the irit of farsightedness that had provided for the building of aries against any shortage. His flattery was rewarded.

When he took his leave of the sovereign a year later, he was in possession of an imperial letter addressed to Pope Nicholas IV which intimated that the khan was prepared to convert to Christianity. Kubilai also stated that he would be glad to welcome to his court scholars, artists, and theologians who could give expression to the greatness of the West in stone, on parchment or in words.

Again the gods protected this ambassador, on his journey to Rome this time, where Nicholas IV assured him that he would satisfy all the emperor's requests. This was forgetting that the Pope had suspicion in his blood. When the time came to embark for Ayas, Montefoschi was escorted by just two ragged monks, and the only treasure he had to offer Kubilai were three drops of sacred oil in the bottom of a phial. He was never able to obtain a second audience with the Pope, and cursing the Church and its servants he drew on his own funds to dress up the two sorry monks as ecclesiastical dignitaries.

As it steered its easterly course towards Lesser Armenia the ship ran into a storm off the Greek coast. Terrified by the apocalyptic tempest, the two fake prelates took refuge in the hold, where the pitching of the ship had them reeling about, wailing and cursing. It was as if they were striken with St Vitus' dance. Meanwhile, Montefoschi helped the sailors to strike the foresail, for the gusts of wind threatened to rip it. The crew lost all hope of escaping shipwreck, but the Venetian did not succumb to the terror spreading among them, indeed the fury of the elements seemed to exhilarate him.

When the force of the wind fell and the height of the waves dropped, and it became clear at last that the ship still had better days to come, Montefoschi welcomed the return to calm: surely his future was blessed by the gods.

In the port of Ayas he celebrated this victory over the sea like an old sea dog. He was to be seen getting drunk at every

unsavoury watering-hole in the city, eyeing the wenches and keeping disreputable company. However, neither the alcohol nor those brief intimacies made him forget his mission to Kubilai. He also continued to fret over his derisory retinue. How was he to impress an emperor with two imbecile monks and a phial of oil as his sole riches? More was needed. It was through his casual encounters in the town that he came to believe that the king of Lesser Armenia could provide what he lacked. Winning him over in order to procure soldiers and a caravan, and − why not? − artists of every kind to accompany him, became an obsession. Traders and sea captains, innkeepers and whores all said the same, and so too did Hovsep, the friend he had picked up on the waterfront: Hethum wanted to consolidate his alliance with the khan of khans. Opportunity makes the thief: Montefoschi would rise to the occasion. So it was that the Venetian arrived at Sis and obtained an audience.

## III

While yet no more than twenty, Vartan Ovanessian, friar and
illuminator at the monastery of Sguevra, won the admiration
of his peers with his illumination of Leo II's Bible. But this
work that glorified the divine and testified to the wisdom of a
king attracted jealousy and hostility. The monastery was div-
ided into two rival factions. One was unstinting in its regard
for Vartan's genius, the other suspected him of heresy. The
leader of the latter faction was a fiery monk who answered to
the name of Artavazd. He concealed his misgivings less and
less after Vartan undertook to illustrate various episodes in the
Virgin's life. Mary's features conjured up a lovesick serving
girl, or a nostalgic widow recollecting moments of tenderness.
Beneath the veils and silk that draped her trembled the curves
of serenely voluptuous flesh. And the sky and the folds of the
Three Kings' garments were shot with glints of wine red.
Such a red, Artavazd decided, was the colour of immorality.
This censorious critic convinced several monks that Vartan
was given to sensualism and ungodliness. A cabal formed in
the chapel and gardens of the cloister. The fault-finder drew
the conspirators' attention to how Vartan would drag his feet
going to church, and to the coldly ironic smile he wore when
taking communion.

Equipped with a candle, gaunt and stooped, his eyes keen
with insane curiosity, the monk made his way one night to
the scriptorium. He lurched along, his hands clutched to his
stomach, as he had been suffering an attack of colic since the
day before. When he got to the writing room, he went
straight to Vartan's desk and brought the candle lower to
examine a parchment. The effect of the wavering flame and
an unsteady wrist was to make an illustration representing the
baptism of Christ seem to quiver. Artavazd gloated. This new

work shamelessly revealed that Vartan was a student and admirer of that sodomite Greek, Straton of Sardis. Christ and the saint focused their gaze neither on the clouds nor the water, but communed with each other through the glance they exchanged. Their nakedness invited physical intimacy. Confident of at last being able to prove Vartan's depraved nature, the monk returned to his cell. But no sooner had he lain on his pallet than he was thrown into convulsions. He was discovered at dawn no longer able to speak and paralysed in his upper limbs: fortune smiled on Vartan.

A few hours later a messenger from the king commanded the illuminator to come to Sis.

Six horsemen followed a road that wound its way between mounds of scree and expanses of low vegetation. Four soldiers formed an escort round Vartan Ovanessian; Hethum's messenger brought up the rear. The soldiers said nothing and their silence suited Vartan who was able to observe the landscape at leisure. The small party passed not far from the castle of Lampron, a fief of the Hethumid dynasty and reputed to be an impregnable fortress. The young man recognized the great forest that he had once skirted, during his adolescence, when his father took him on a tour of Lesser Armenia. Today, as then, he experienced a fierce sense of freedom.

Kevork Ovanessian was related to the Hethumid family. He was only modestly wealthy, although he had a house of respectable proportions, servants and a herd of livestock. He was an abrasive individual, subject to violent rages, and little given to conversation. Yet he was also a dutiful man. Uncles and cousins would sometimes break their journey passing over his land and in the evening round the fire reported what was happening in the kingdom, informed him of the signing of a treaty, a new alliance, or a likely war. He always remained somewhat distant with these visitors. Kevork only abandoned his reserve with his two sons, Haik and Vartan, in whom he

instilled a spirit of prudence and loyalty to their sovereign. But he did not restrict himself to imparting wise counsel. To the study of virtue, he added the practice of bearing arms. After a bout of swordplay, he would tell them of past massacres that the Seljuks had carried out against the Armenians, thereby striking their imagination with visions of fire and blood.

Haik was the first to leave the paternal home to serve as an officer in the army of Leo II, Hethum's predecessor. Vardan's training in the use of arms had the opposite effect on him. Galloping across a battlefield held out little appeal to him; his sole aspiration was to devote himself to the art of illumination, which he had come across, as a child, in a prayer book. And this art could be practised only within the walls of a monastery. Kevork consented to his son's wish. Yet he warned him never to forget that, like a soldier, a monk should know how to wield a sword and decapitate a man with a battle axe, for cloisters no less than palaces are vulnerable to attack.

Before the gates of Sguevra closed behind Vartan, Kevork made a journey through Lesser Armenia with his son. He wanted him to have a real idea of his native country and be able, at the foot of a cross, to intercede with God so that this land and its beauties might be protected from invasion. So they travelled many byways, living on a diet of dried fruit and dried meat, filling their goatskin bottles with river water, sleeping at Tarsus, Adana, Mamistra, Sis and Ayas. In the ports Vartan became familiar with the waterfront hubbub and the mingled smells of saffron, pepper and ginger. Near the stalls, he gleaned fragments of conversation referring to the brothels of Tabriz, the pottery factories of Kashan, the high dunes and yellow fog of Tarim, and the bath houses that every village in the north possessed. Listening to the merchants' shared reminiscences awakened in him the desire to explore countries whose existence he had not even suspected until that day. He thus became aware that the world was not contained within

the walls of a monastery and he now doubted that he could be satisfied with a single place and with devoting himself to a single task. But he did not tell his father that he was wavering in his convictions.

Their trip lasted four months. Shortly after returning to his family home, Vartan joined the brotherhood of Sguevra.

The small party was approaching Sis. Vartan was no longer thinking of the monastery where he had spent four years of his life. His attention was entirely absorbed by the recurrent sameness or diversity of the landscape, by the sound of hoofs on sand, gravel or stone, the rustle of a garment with a flap folded over a thigh, the play of muscles beneath a fur. He vowed one day to capture with his paint brushes the fleeting movement of things. And he remembered the merchants' talk in Ayas. Indeed, that recollection had very often filled his nights and fired his imagination. Unlike the other monks, Vartan by no means dreamed of being seated among the saints and archangels after a life of penitence. He sinned by his indifference to everything that was not his art, and for this he felt no shame. In his cell or at his desk, he agonized simply at the thought of not being able to reproduce the downy green of an almond, or the redness of a wound. At Sguevra as on the road to Sis, he had but a single obsession: to paint the splendours of the world.

And now, here was the capital of Lesser Armenia, lying before him, with its crowded hovels, patrician houses, palace, and gardens. He saw women at a well and children crawling in the dust, men begging and dogs sleeping in the shade of a tree. Behold the universe, he said to himself, where marvels occur and the living die.

# IV

The caravan made a stopover at Sis, where Hethum II provided it with a leader in the person of Vicente Montefoschi. The king also raised a militia for the protection of Vartan and the merchants, at least as far as Tabriz, for beyond there, the roads of the Mongol Empire have the reputation of being safe. The only danger comes from demons that inhabit the deserts and valleys. The best-tempered steel, a heart of the utmost staunchness against temptation cannot withstand the fury of their assaults. But sometimes these countless demons pay no attention to travellers. They keep out of the way, in the skies or among the foliage, invisible and silent. Yet fear is the faithful companion of whoever crosses these plains and climbs these mountains. Monks, merchants, soldiers, all had some presentiment of what the roads of Asia — muddy roads, or green with thickly-growing grass, roads strewn with ruins — inevitably held in store for them. Dreams or celestial signs had convinced them that their body and soul would have to undergo some kind of metamorphosis, for better or worse. And, despite these dreams and forewarnings, they had all set off in search of riches, ready to brave the darkness or dazzling light of a country with no name.

The caravan occupied the marketplace of Sis, and spilled over into the neighbouring streets. It would soon be departing. Acrid dust raised unremittingly by men and beasts swirled round hoofs and legs like billowing yellow smoke. Gathering uncontrollably, shrouding bodies and heads, it soon formed a large cloud that moved in flurries, shimmied, rent here and there, yet nonetheless continued to rise towards the rooftops. The merchants' restiveness created a strange impression of a storm. The horses, mules and donkeys kicked and pawed the

ground, the camels were ill-tempered. Flemish cloth smelling of chalk was baled up. Gold and pearls were concealed in the lining of belts. Voices jabbered or shouted out amid the confusion: shrill voices, hoarse, drunken voices; the voices of Spaniards, Frenchmen, Jews and Armenians. They were voices of exasperation and impatience. There was also a lot of gesticulating. A finger was pointed to a bridle, some stirrups, a sore on an animal's flank, a chest too slackly roped, an inadequately-cleaned weapon. In one corner of the square three interpreters, unheedful of the commotion, were drinking a pale wine. Women carrying jugs, and offering water or some alcholic beverage, threaded their way through the crowd. A Frank with a fondness for whores who foresaw his own death – his eyes already had the brilliance of petrifying ice and the blazing heat of suns – arranged to meet them in a hundred years' time.

Vicente Montefoschi finally appeared, followed by Vartan. It was clear, the Venetian commanded respect because of his friendship with the king of Lesser Armenia, the Pope, and Kubilai. His arrival announced that the time had come to leave the capital and set out for those cities where an emerald is traded for a fur, a catamite for a half-bottle of wine. Febrile and anxious, childish and ruthless, hidebound by prejudice and thirsting for adventure, steeped in their faith and yet superstitious, their imaginations glutted with tales of Alexander and their heads crammed with figures and clever calculations, the travellers awaited the signal for departure. A great ripple of euphoria ran through the square when Montefoschi mounted his horse. The merchants and guides mounted in turn. It was a sizable caravan of no less than sixty men that ventured forth, leaving Sis to its own fate.

# V

Montefoschi was nursing a deep anger. The two monks – that
sorry retinue with which the Pope had provided him – had
fled the day before. The wimpish pair were scared by tales
they had been told by the sailors of pillaged lands and tortured
bodies. But these poltroons had cunning and commerce in
their blood: they had taken with them the rich garments their
master had bestowed on them, in all likelihood with the inten-
tion of selling every last decorative braid, stitch of embroidery,
thread of gold. Montefoschi little doubted it, and he hoped
they would be sold into slavery. Moreover, his anger was
mounting because Vartan Ovanessian persisted in trying to
engage him in conversation. He kept asking questions, declar-
ing out loud what he could see, a misty horizon, fields,
marshes. Montefoschi detested talkative young men. At last
Vartan grew tired of addressing a mute, and he too retreated
into silence. He recalled the dinner on the eve of their depart-
ure that had brought together a monk, a merchant and a king.
He had the opportunity during the course of that meal to
observe the Venetian. An imperious, inflexible and disturbing
power emanated from the man. At the end of the evening,
Montefoschi had unfolded a map drawn up by a native of
Cairo. Tracing with his finger the route that he and Vartan
would take the very next day, he pointed out towns and rivers,
mountain ranges and deserts. The more places he named, the
more distant his voice grew. It was the voice of a man surren-
dering to a dream. Having watched him, Vartan said to himself
that Montefoschi had the stature of a king. But his intuition
told him more: this was a king whose reign would be short-
lived, riding through cities destroyed by fire and beside silted-
up lakes. Suddenly he experienced a feeling akin to friendship
for the Venetian. He was prepared to accompany him to that

place where a dynasty was born from the coupling of a blue wolf with a hind, where gates of gold stood, where the world seemed perhaps boundless. And then he too became lost in reverie.

That night Montesfoschi sat next to Vartan, by the fire, and coming straight to the point urged on him a vow of silence during the day, because talking non-stop increases thirst, soon causing chapped lips and a searing pain in the chest. Thus, rashly loquacious merchants, with burning throats, had been compelled to hold their tongue. All they wanted was to die. And, as if talking to himself, he added that some confidences are unnecessary and some enthusiasms futile. He then gave a brief laugh and walked off.

Vartan remained by the fire for a long time and did not fall asleep until it began to grow less dark. Montefoschi unceremoniously shook him awake at dawn. A few hours later the caravan entered Turcoman territory. There were fields of cotton and wheat, oak forests and a sheet of water suddenly tapering between the rocks like a flow of cool lava. At last, beneath a very blue sky and amid a murmur of fountains, the town of Kayseri came into view.

# VI

In the courtyard of the caravanserai at Kayseri where our travellers halted, sheeps throats were cut and fires were lit. A smell of scorched fur, leather, blood and fat permeated bodies, trees and the shadows that shrouded the pack animals.

The keeper of the caravanserai chided a cohort of servants and errand boys. He scrutinized Vartan at length on his arrival. Bowing before him, his gaze strayed from the woollen robe to linger on the cross that hung on a cord round his neck.

A youth brought a plate of meat, some fruit and pancakes to the room where the young man was now resting. He stared hard at the monk, as one might scour the face of an enemy. Suddenly, with a movement no less devious than unerring, he lightly brushed his hand over the cruficix. Vartan recoiled instinctively: no stranger had ever previously touched the humble wooden token. The gesture also annoyed him, as he did not welcome any display of familiarity. The youth was still staring at him with the same hostile look in his eyes. He muttered a few words in a tone of unambiguous insult, then left. This peculiar behaviour, of no great moment in itself, brought to a peak an apprehensiveness that had been brewing in Vartan for several days. He examined the room in which he was to sleep. Everything, from the mattress to the shadows, seemed fraught with menace. He clutched the crucifix to his breast. But this had little effect on his sense of unease. Whether in Sguevra or Anatolia, it was of absolutely no consolation to him in his moments of anguish.

The sight of food upset him. He stood at the window breathing in the cool night air. There were traders arguing in one corner of the courtyard. Fires glowed, as on the plains where nomads gather and carouse together. Vartan moved away from the window, certain of being watched. It was then

that Montefoschi came through the door. The Venetian noticed that he had not touched his meal, that he was pale and tense. Nevertheless, he made no comment, setting a bundle at the end of the bed, which he immediately began to untie. Then laying out some clothes on the floor, he explained that these were merchant's clothes and from the very next day Vartan was to swop his homespun cassock for the finer-cloth cloak. War had long held sway in the lands they were about to traverse, leaving the humblest peasant aggressively disposed. And Muslims readily slit the throats of Christian priests and monks. Peace now reigned, but an ancestral hatred lurked behind the marks of hospitality, Montefoschi concluded. With these words of caution, he was gone.

When he woke up, all that Vartan could remember of his dreams was a purple foot. This foot reminded him of someone and that someone was his father. The day after they returned from their instructive trip round Lesser Armenia, Kevork acquired some new habits: from then on he took his meals in his room, from which his wife and son were barred. No one but Rhipsimé, a serving girl, was allowed in. Intrigued, Vartan questioned her every day about his father's state of health and the tasks that kept her so long in his room. She admitted spending most of the time nursing a suppurating wound on her master's right foot. And there was even more she owned to: cleaning the pus and cutting away the dead skin with a knife did not disgust her. A week had passed when a linen maid started spreading the rumour that Rhipsimé had fallen out with her young man. Vartan had a strong sense that all these events were linked and this mystery filled his thoughts. One night he half-opened the door of his father's room. What he saw surprised him beyond all expectation. Rhipsimé, naked, held Kevork in her arms. He was moaning, and the girl cradled him in his lingering death. Sticking out from the sheets and blankets was an emaciated leg. A smell of rotting

28

flesh emanated from the foot that was pitted with sores. Vartan fled from the sight of it. A month after he joined the community at Sguevra, a letter from his mother brought news of his father's death. In the same letter she described how Rhipsimé had died. While tending to a hive, the serving girl had been attacked by the insects and stung to death. To dispel the vision of that naked body embracing the old man, Vartan had embarked on the illumination of Leo II's Bible. Lying in his uncomfortable bed in that caravanserai in Kayseri, he relived that night when love and nakedness had kept company with death at a man's bedside.

The time had come to prepare for departure. But Vartan lacked the will to do so. He silently wept at the memory of his father and Rhipsimé. His recollection of their calm embrace suddenly confronted him with the existence of a feeling he still dared not name and yet hoped one day to experience. When emotions welled up inside them that their superior condemned as a persistent spirit of lewdness, the monks of Sguevra would hasten to submit themselves to self-mortification. Like the others, Vartan imposed penances on himself. The greatest privation of all was to give up going to the scriptorium. However, at prayer in his cell, he inevitably dreamed of the happiness that he might have been enjoying preparing pigments or painting St John's cloak, a happiness that he was denying himself. If he rebelled against any such self-mortification now, the reason was simple: nothing seemed to him more moving, more necessary than love – for that was the bond between Kevork and the serving girl, and he envied them. And he was eager to discover the cities of Persia and the East, to experience at last what a very young woman and a dying man had experienced.

The heat was intense, like that of pebbles on a dried-up river-bed. In the courtyard of the caravanserai a sultry wind with a

sandy warmth stirred the suspended harnesses and loops of rope. The stench of excrement mingled with the fragrance of precious woods. A soldier rubbed down his horse with a handful of straw. There was a streak of azure blue across the grey sky. Buildings, beasts and men looked like polished glass. The streak of azure grew even bluer. The light was like a summons, an invitation to adventure. In his room Vartan removed the crucifix from round his neck and dressed himself as a merchant.

# VII

The Seljuks, recently conquered by the Mongols, had abandoned the plains of Eastern Anatolia and repaired to the mountains. Large flocks of sheep grazed on the yellowing-green stubbly grass. A few shepherds stood out against the desolate landscape, dark enigmatic figures, spectral in broad daylight.

Sivas was a flourishing trade centre, thanks to carpet-weaving and the production of silk cloth. The caravan stayed there four days. Then it travelled on, across bleak expanses with game in abundance, beneath a sky of fleecy cloud graven with the wheeling of eagles. Between Sivas and Erzincan lay horse carcasses, with shreds of blue cloth clinging to them. Battles had taken place here, but time had passed and the sands had absorbed the blood spilled. Travellers returned to these routes months ago. Under the trees, on the outskirts of villages, women ground corn with a pestle. Weasel-faced, they showed no emotion. Near-naked boys reaped tall cereals the colour of light amber. The fields undulated like sea monsters. Sometimes the caravan passed another coming in the opposite direction. Not a word was exchanged. The men did not even turn to look at each other.

The landscape was unchanging. There was nothing to arrest Vartan's eye, other than an opaque-green hillock, reeds like blowpipes stuck in the clay, a cloud of insects, a child climbing a path. He seemed to be reciting prayers, as though chewing a stalk, but anyone able to hear would have realized this was not at all the case. He was murmuring the praises of Rhipsimé and Kevork, and between sighs celebrating the servant's blue dress and his father serene gaze. Now and then Montefoschi secretly observed him and was surprised to see him wearing his new clothes as if he had been a merchant all

his life. In his heart of hearts, Montefoschi was glad to be Vartan's guide.

Two days' journey from Erzincan, a man appeared from nowhere, gesticulating and muttering warnings. When one of the caravaneers tried to approach him, he scuttled away. Soon he was no more than a black line moving across the scrubland. Vartan forgot him, as he had forgotten the horse carcasses and the eagles in the sky. His attention was focused on the caravaneer talking to Montefoschi. All he knew about him was that his name was Hovsep, and that he was from Adana. Vartan moved closer: he was intrigued by the way Montefoschi listened to this man. The Venetian lent towards him earnestly, indeed with kindness, even seemed not to mind that his companion talked in a loud voice, which was surprising in view of his predilection for silence. Hovsep said that, if the man who had appeared from nowhere was to be believed, plague was ravaging the settlement that could be seen not far off.

The horses were exhausted. And darkness was falling. A halt was clearly necessary. So Montefoschi ordered the tents to be erected a short distance from the village. Soldiers took up posts at regular intervals in front of the them, to prevent any intrusion into the encampment of a population fleeing the epidemic who might have tried to take refuge with the travellers.

The evening meal was subdued. Everyone wondered whether Erzincan, the next stopping place, was suffering the same scourge. The mercants blamed Montefoschi for making them pitch camp so close to a place of abomination. But according to the Venetian, travelling at night was out of the question, especially with these jaded beasts. For the first time Hovsep sat beside him, using his knife to sharpen twigs from a bush he had uprooted. From time to time he would throw one of these makeshift arrows at a merchant. The response

would be a shrug of the shoulders or amused protests. Having tired of whittling wood and intimidating the others, he got to his feet, declaring that the plague was a sheer invention of his, then he went and crept into Montefoschi's tent, where he was joined shortly afterwards by the Venetian. This disclosure was met with amazement and anger. Then there was an explosion of laughter. Everyone seemed to have got used to his lies and pranks.

Vartan remained in his tent for a little under an hour. The puzzle of Hovsep's identity kept him awake. He could not be a merchant: he had no mule or camel and his baggage consisted of no more than two small bundles. The obvious connivance between him and the Venetian did not in any way clarify the puzzle, but rather increased its obscurity. When in his presence, Montefoschi sometimes wore an expression of anxiety and frozen grief. Long before dawn Vartan crept up to the Italian's tent. All he could hear was the sleepers' breathing. He was emboldened to lift the tent flap: two dark forms lay at some distance from each other. Vartan was disappointed. But from now on he would not rest until he had unravelled the secrets surrounding the Pope's ambassador and this mysterious fellow Hovsep. Vartan intended one day to paint the Passion of Christ. The two thieves would have the faces of Hovsep and Montefoschi. As for Christ Himself, he had not yet encountered the face in which the suffering of His last agony was to be revealed.

That same night a merchant decided to leave the caravan at Erzincan. No longer very young but of robust constitution, the man, Roger de Narbonne, felt none the less certain that he would never reach any great age. And he whose calm and restraint had won admiration on a thousand occasions tried desperately not to cry out his fear.

From the moment they left Sis, he had recognized in

Hovsep the agent of his imminent demise. For the past ten years Hovsep had harboured a fierce, stubborn, absolute hatred towards him. When the Armenian was arrested for theft, and at his subsequent trial, Roger de Narbonne's testimony had weighed heavily on the judges' resolution and made them decide to inflict an exemplary punishment. A month later Roger learned that Hagop Karagueuzian – a relative of Leo II of Lesser Armenia – had intervened, using his fortune, influence at court and high moral authority, to persuade the king to free Hovsep. In this he was successful. The briefly imprisoned offender then served as valet in Hagop's household. The royal pardon came as a blow to Roger de Narbonne, for sooner or later it would place him at the mercy of the thief's desire for revenge. So from then on, he curtailed his trips to Lesser Armenia, where his trading interests often called him.

As ill luck would have it, the Armenian joined the caravan with which Roger de Narbonne was travelling. As soon as he saw him, Roger told himself that he had better give up this trip. Indeed, ever since the fellow had regained his freedom, Roger's existence had been dominated by a single state of mind: fear. It had fully invaded his body, his thoughts, his dreams. But there was also something in the man that rebelled. A seer had actually predicted some time ago that he would be attacked by an enemy. Was he therefore to submit to his destiny, appearing in the form of a sinister thief? Could he not overcome this diabolical fear, so that the prediction might turn out to be false? Since their departure from Sis, therefore, he had been putting on a bold face and braving the danger that threatened him.

Montefoschi had not spoken to him any more than Hovsep. Suddenly seeing the two men in discussion revived his anxiety. Particularly as in Sivas he had overheard fragments of a conversation between some merchants under the shade of a tree. So it was that he realized a conspiracy was being plotted against him, at Hovsep's instigation. The latter had convinced

them that Roger de Narbonne would use his entire wealth to buy so much cloth of gold and silk in Tabriz that this would lead to a rise in prices, bringing many of them to ruin. Listening to this tale, fear overcame him as never before. But it was impossible for him to escape, as the merchants kept watch on him the whole time. He began to count on an eventual relaxation of their vigilance when they next broke their journey.

Mountains wreathed in haze, and diamond-studded purple evenings; flocks of sheep with their shepherd lads, carcasses lying in a vast undulating expanse: and so it would continue, on and on, all the way to Erzincan.

Every night, Roger de Narbonne denied himself sleep. He would lie, uneasy, on the ground, not far from the Armenian soldiers, never straying away from the fire except to relieve himself. And the soldiers would jeer at this man who bared himself in front of them.

During one stopover he even went so far as to goad Hovsep with some acerbic remarks, but the other feigned deafness and Roger achieved nothing, only finding himself the victim of a discreet but genuine ostracism on the part of the caravan. He wondered whether Vartan had been asked to join the conspiracy, if the monk had not the black-heartedness of the merchants, adventurers and ambassadors.

At the gates of Erzincan, Roger de Narbonne plucked up the courage to address Vartan. He begged for a word in private, which to him was of the greatest importance to his salvation. Vartan at first took him for one of those people whose imagination, tormented by the dread of hell, turns the slightest lapse into a mortal sin. But inspired with the hope of finding an ally in Vartan, the expression in the man's eyes was completely unclouded by frenzy, or panic, and reassured the monk. So Vartan agreed to his request.

The conversation, or rather the merchant's monologue,

took place in Vartan's room in the caravanserai at Erzincan. Roger had a fairly good command of Armenian. Coming straight to the point, he listed the towns where he had made money, and those where swindlers had got the better of him. He patted his broad belt with an ironic smile. A small cache, which he soon laid out on the ground, was sewn into this band of blue cloth: pearls, gold coins, and a brooch set with rubies. If by any chance he were finally to make up his mind to return to Narbonne, this brooch would go to his wife. It was because he had listened to the tales of pedlars and traders – tales of rivers greener than emerald or the grass in spring, of towns that glittered like steel – that he had forsaken the marital bed, the conjugal home and orchard. He sometimes convinced himself that it was his duty to return to his native province, and by the same token to his wife and two sons. But it was only a fleeting thought, for he was captivated by the fabulous lands that he roamed and he never had the heart to forgo the contemplation of a sky where thunder, plague and angels surely originated. He loved the dusty roads and the strange creatures living in the forests and deserts. He loved the sleeping monsters in the dunes and the smell of war that permeated the trees and earth. A few pearls, some gold, and a brooch: this was his entire fortune. And as Vartan could see, his hands trembled and sweat poured from his brow. He was racked with fear. The Furies were at his heels. He was hated, there had been scheming for his death. Madmen were gathering all around him. And then there was Hovsep and his vengeance.

'Hovsep?'

Vartan's voice was very soft.

Roger de Narbonne was silent as he rewrapped his meagre treasure in his belt. For a few moments, before the impassive monk, he had recalled a great deal, and openly regretted his orchard, his wife and their two boys. But the curiosity roused in Vartan by the mere name of Hovsep drove away his nostalgia. An invisible presence, that of Hovsep himself, had slipped

between them, so at least it seemed to Roger. He was overcome with dizziness and felt profoundly weary. His days of travelling were coming to an end. And again, in his heart of hearts, he found himself accepting the idea of his death and the manner in which it was to occur. It was a defeated man who rose abruptly and without excusing himself left the room.

Protected by a boundary wall bristling with watchtowers, Erzincan stood on the right bank of the river Karasu. One June day, in the midst of the vines surrounding the Anatolian city, a peasant stumbled upon the body of a man, with his throat cut, his genitals amputated, and his head reduced to a red pulp of bones and flesh. He was totally naked. The state of his face and his complete lack of clothing made any kind of identification impossible. The peasant had three sons. The four of them conferred. They were reluctant to inform the governor of Erzincan of their discovery. They still remembered one of their cousins who was confronted with a similar situation. The boy had told the town authorities of a man he had found lying in a field, with a gaping wound in his chest and his legs torn to shreds. A Seljuk, who was adviser to the governor, had accused him of deceit and brazenness. The wounds had been made with a bill hook. And who but vinegrowers used such a tool? Accused of murder, the cousin had been decapitated. The peasant and his offspring had learned from this. They carried the body home, and in the dark of night threw it into the waters of the Karasu.

No one reported Roger de Narbonne's disappearance to the Armenian militia or to the governor of the town. But one morning Vartan came upon Montefoschi, Hovsep and a few merchants gathered round Roger's mules. Hovsep ran his hands over the beasts' legs and flanks, just like a horse dealer. The bales of cloth were then shared out between them, and each returned to his own affairs.

# VIII

It was late afternoon. The sky was dyed orange and the snow on the mountaintops had a pearly sheen. The merchants having deserted the caravanserai – the Persians were at the baths, the Jews and Franks were trading Flemish cloth for silk brocade – Hethum's soldiers were the only remaining occupants. Made lethargic by a breeze carrying the smell of fodder and baking-hot stone, with a final exertion they worked out how many days before they reached Tabriz and how many nights before their return to Lesser Armenia. Their captain told rambling stories in which the abduction of women, horses swifter than lightning and glorious feats of arms created a landscape reminiscent of the age of Alexander.

Montefoschi and Hovsep had set off through the streets of the city to deal with some private matter, or perhaps simply to mingle with the crowd and wander about. Vartan wanted to go with them. The Venetian refused to let him, for the illuminator's pallor betrayed a tiredness close to exhaustion. He had no wish to bring before Kubilai a blood-drained monk. In truth, Montefoschi was planning to introduce Hovsep, unobserved, to the splendours of a town that he himself had previously visited.

Left behind on his own, a disappointed Vartan drifted through the halls and kitchens, inquired of the soldiers what amount of food supplies were needed to reach Erzerum, and finally ate some green walnuts preserved in grape syrup, for he was by nature a glutton. At Sguevra, he deliberately kept away from the larder so as not to yield to his cravings. But here in the caravanserai where monastic rules were no longer in force, he gorged himself on honey and pastries. Despite this indulgence, his disappointment persisted. Ultimately everything bored him. He abandoned the gloom of the corridors and the

furnace-like heat of the courtyards, ending up in his room where he immediately flopped onto his bed. From his small chamber, where an autumn coolness prevailed from morning till evening, he could hear the great swell of the town's distant clamour. It roused his senses, tempting him to go for a walk. Stretched out on his mattress, he felt no tiredness and became outraged that, taking his authority a little too far, Montefoschi should assume the right to decide whether or not he was capable of putting one foot in front of the other. Then he made up his mind that he too would venture into town. Having taken this decision, his spirits lifted. He dug his homespun cassock out of a chest. It was creased and stained, and the bottom of it stiff with dried mud. Beneath his discarded habit, he tied a rope round his waist from which hung a purse full of the dirhams that Hethum had given him just as he was leaving. So, through a king's generosity, Vartan's penury was only apparent. When he reached the gate of the caravanserai, he exulted in defying Montefoschi's orders, in being a monk when he wanted, and becoming a merchant again when it suited him.

Erzincan rose up in terraces. The uppermost were bathed in crystalline light, the lowest sunk in a turmoil of dusky shadow. Vartan hurried to leave behind the velvety gloom of the latter, heading for the glorious gold-veined mauves and blues of the former. He made his way through a marine world, an expanse of glittering reflections. He admired the splendour of the evening over the town, but now and then Montefoschi's face floated above the thresholds of the small shops, on blind walls, on stones consumed by the falling darkness. He then dismissed these visions, committing himself solely to the desire to paint Erzincan as the new Babel, or the celestial city.

Here, Vartan felt as if he had born for the hustle and bustle of the world and encounters beyond number. He wandered through this labyrinth at his ease. Like Ayas, Erzincan in this

late afternoon buzzed with premonitions, promises and illusions.

He was overcome with faintness as he reached the last terrace. He leaned against a wall, with his forehead resting in the crook of his arm. Pain cut through his heart, and he had not the strength to cling to the wall. He sank to the ground, slowly taking up the position of a soldier kneeling in the dust, whose shield could not have protected him from a sabre.

Onlookers gathered round the unconscious monk, when out of the group of curious spectators stepped forward three of Hethum's soldiers. As he passed through the gate of the caravanserai Vartan had not noticed these three men following on his heels, for they had been ordered by Montefoschi to watch over his safety, if by any chance he were to take it into his head to venture into town. They carefully lifted him and set off down the terraces to carry him back to the caravanserai.

Now another's hand loosely held his own. The gentleness of this gesture did not reduce the terrible surges of pain piercing his chest. Someone bent over him a little closer, as if trying to catch the echoes of deeply buried suffering. He was startled, recognizing Hovsep. The hand dropped his and clasped his wrist. Irrationally, he was overcome with apprehension. It settled on the band of burning pain running from his waist to his shoulder. He groaned and the hand withdrew. Hovsep's eyes conveyed no emotion. They were the eyes of a doctor gauging the resistance of a fellow human being to the encroachment of an illness.

Hovsep touched his face lightly with some gleaming object. There were letters engraved on it, or a seal. The object glistened in the dying light of day: an ancient mask or a breastplate; or the sole relic of a lost civilization. Hovsep explained: it was a gold tablet that served as a safe-conduct throughout the entire Mongol empire. Kubilai had given it to

Montefoschi. An identical one was kept locked in a chest. They impressed barbarians and brigands more than the glint of a sword or the Armenian militia. They guaranteed protection and respect. In some way they conferred on a traveller a history, a rank, a destiny. Brandishing it immediately procured horses. They were useful on a such a long journey, for in the heart of deserts and in cities harrowed by the winds, who knows anything of the realm of Lesser Armenia and its most pious king?

Hovsep pressed the tablet to the invalid's lips, cheeks and brow. The gold was warm, like a fruit beneath the midday sun. This strange ritual shocked the monk. He had never before kissed anything but a crucifix. But his overwhelming fever made him drift into deep drowsiness.

Hovsep laid the gold tablet on the ground so as to observe Vartan unimpeded. Then with searching hands he examined Vartan's chest as the young man appeared to sink into a strange slumber. Vartan closed his eyes on being touched, but with his arm pushed away the hands now lingering on his shoulders. Hovsep made no further movement. To his surprise, Vartan suddenly pulled him close. Then the hands resumed their exploration. A finger traced the outline of the sick man's lips, a fingernail ran across the planes of his face, the bridge of his nose, his temples. The hands strayed over his thighs and stomach, finally ceased their wandering over his flesh. Hovsep felt no desire whatsoever for this tall quivering body. He was simply reassured: the young man's nakedness was not of the kind that excited Montefoschi. Vartan opened his eyes and Hovsep divulged a little of his past. He made no secret of his misdemeanours, but said nothing about his crimes. In a whisper, Vartan asked him to leave the room.

Twenty times a day he fell into a sweat. Montefoschi despaired of the patient's condition. All his attention was now focused on the monk whose death he refused to allow, for he dared

not imagine himself bowing down before Kubilai without the illuminator at his side. It meant running the risk of being nothing more, to his contemporaries, and to those who wrote the annals of an age devoted to trade and steeped in ardent faith, than a vulgar adventurer, just another of those men crazed with ambition and besotted with insane dreams.

One morning Vartan's knees were ringed with little reddish sores, and furthermore he was subject with increasing frequency to fits of muscular seizure. Vartan suffered without complaint and Montefoschi admired him for it. But the drugs administered and the poultices applied by the doctors failed to clear his abscesses and quell his fever.

Their departure from Erzincan had been delayed by a week on the Venetian's orders. Having to extend their stay until a monk regained his health infuriated the merchants. As a matter of prudence they did not yet protest openly against this decision. Montefoschi enjoyed Hethum's protection and the Armenian soldiers would not refrain from reporting their anger and unruliness to the king. Their commercial future in Ayas was likely to be compromised. And most of them felt constrained by the memory of the part they had played in the murder of Roger de Narbonne. They were anxious to reach Tabriz, attend to their affairs, join another caravan that would take them to a Mediterranean port, and to be what they were: bent on gain, wily, respectable. Hovsep got wind of the merchants' growing ill feeling and warned Montefoschi, while at the same time reassuring him: he could calm their irritation by drawing on all the resources of his cunning. So it was that he bribed the beggars and Armenians of Erzincan to spread a rumour that terrified the travellers. The story was that a pack of carnivorous horses was attacking caravans a little way beyond Erzerum. An astrologer whose palm Hovsep greased added that the pack turned up every hundred years and created carnage for a period of only eighteen days, then

plunged into a river and drowned. This fabrication born of the suborner's imagination had the desired effect. The merchants chose to show patience.

Montefoschi began to entertain great hopes of a doctor who had recently arrived in the town. Joshua, a Jew of Erzincan, adept in the preparation of medicines, assured him that this man had the skill to cure Vartan Ovanessian.

The first sight that Montefoschi had of Arnaud de Roanne was of a man of slight build, wrapped in a big blue silk cloak, his face consumed by the luxuriant growth of his beard, issuing instructions to a young boy with regard to a kind of leather valise and a chest that he was untying from the back of a camel. The man seemed to be an even-tempered fellow, not much older than thirty. After giving his master a prolonged hug, Joshua introduced the two men, and sang the praises of both, expressing the hope that Arnaud's arrival in Erzincan would be a benefit to all, the sick as well as the most hale and hearty. Montefoschi had not failed to mention to Joshua any of the schemes inspired by his exceptional ambition and unremitting combativeness. He had dreamed aloud before a stranger, explaining at length the role Vartan was to play at Kubilai's court, and consequently the necessity to keep him alive. Joshua repeated word for word what the Venetian had imparted to him, but embellished with digression. Arnaud de Roanne seemed unimpressed by his former pupil's account and lyrical effusions. Like so many others whose hopes and aspirations he had listened to, the Venetian no doubt cherished illusions. Montefoschi noted this unwillingness to give credence to his prodigious destiny, and took offence. So as not to yield to aggressiveness, which might lead this doctor to refuse to treat Vartan, he settled the conversation on more prosaic ground: he mentioned the price he would pay, if the medicines proved effective, of course. The Frankish doctor ignored his offer. Instead, he asked if the Armenian had brought with him any of the sacred books that he had

illuminated. Montefoschi affirmed that this was so. Being allowed to look at them will be my fee, was the reply.

It was an extraordinary setting, of stills and burettes, coloured flasks and weird-shaped ladles, in which Joshua had described to Montefoschi his encounter with Arnaud de Roanne. For one whole spring, he had been his pupil in Byzantium. From the coasts of Spain to those of Italy, from the Auvergne to Anatolia, from the ends of the earth to Persia, this doctor was admired, envied, and begrudged for the results he obtained in the dying and the insane through their intake of a prescription of his devising. After swallowing one of his potions, dying men would rise from their beds to go gardening or wield a chisel, and the mad would display no further sign of their usual agitation. This Frenchman, born in a town on the banks of the Loire, in a landscape where vines vied with heather and broom, was reviled by bigots of every kind because he drew his knowledge from treatises written by heretics, without shying away from questions when asked about the provenance of his sources, too concerned as he was to convey to the urban pedant or the provincial boor the fruits of his research conducted in libraries, among desert nomads or sorcerers from around Kiev. This extraordinary learning, acquired within some fifteen years, went hand in hand with a passion for conducting seemingly the most hazardous experiments, and with genius. A single glance revealed to him the inside of a body. But what exposed him most to abuse from his enemies was that he did not believe in divine punishment. He did not subscribe to the certainty or the hypothesis that a paradise exists beyond the stars, and a hell blazes in the earth's darkness. Joshua the Jew denied that Arnaud was what men of ignorance and incompetence accused him of being. The miraculous oil that his master used to dispel dementia or death from bodies wracked with pain, Joshua concluded, was fiery hot and gently soothing.

<div align="center">*</div>

Before visiting his patient, Arnaud de Roanne expressed the desire for sustenance. In a small room, he drank some Shiraz wine and treated himself to half a roast chicken and some dates that he dipped in a pot of honey. His hunger and thirst satisfied, he made the blue silk cloak that he seemed to wear all the time billow out round his legs and waist. The undulations caused by his swirling motion, the rustling of the fabric and the sense of a soft breeze on his hips and thighs made him think of leaves – signs that attended him whenever he was going to have to confront suffering and death. But these visions could not withstand the cries of the insane or the groans of the crippled that he carried inside him. So he would return to this world teeming with women stricken with consumption or men constantly scratching their scorbutic sores. And this battle filled his life.

He sounded Vartan's chest very briefly. He set a copper bowl on a bronze tripod, in which a lancet rattled when he brushed past it. He used this instrument only with reluctance, when ointments and drugs failed to reduce fever and heart palpitations. And he had noticed how the sight of the lancet always reassured his patients. Having completed his examination, he took from his bag a crudely bound book with blank pages. Dried out between them were herbs and other plants that he had come upon in the course of his wanderings across the moors in the North or the plains of Persia. Even the most ignorant doctor could have named the hysop and borage, identified the coltsfoot and lungwort. Arnaud crumbled stems, leaves or flowers into a small pot with water boiling in it. Then he added to this aromatic mixture some liquids contained in phials. When he was satisfied with the potion, he administered it to the sick man in small doses. After every sip, he put his ear to his patient's throat, stomach, or chest, listening to his body fighting the illness, often defeating it. He propped the goblet in which the potion was slowly

thickening between the patient's thighs. The goblet was clouded with beads of sweat exuding profusely from the exhausted flesh. Arnaud de Roanne then performed on Vartan the rituals of his calling. Finally he made the monk swallow a soupy tisane. His movements were authoritative, his words gentle. Vartan's silence soon gave way to verbal delirium. Unconnected words kept pouring from his lips: wormwood, urn, foot, crosier, broth . . . His incoherent logorrhea ceased with the ebbing of pain that was crushing his chest.

Montefoschi and Hovsep watched the doctor's mysterious doings. If the former had turned to the latter he would have taken in at a glance the catastrophe that lay ahead. The blue silk cloak fascinated Hovsep. Happiness welled up deep inside him. In this room where the cure of a monk was more than likely to be effected, he blotted from his memory, or so at least he was convinced, a turbulent past that bore the dark wound of humiliation.

Every five minutes Arnaud de Roanne lit a candle, so that in a little more than an hour the room was steeped in a luminous blaze. In this warm light encircled by undulating shadows, Vartan returned to life. Montefoschi felt as worn down as he had been after facing the storm off the coast of Greece. He sought comfort in his travelling companion, but Hovsep was not there any more. He did not display his displeasure or disappointment. The time had not yet come for him to be surprised by any absence, endlessly to turn over in the mind the reasons for it, to find himself incomprehensibly abandoned.

He offered Arnaud de Roanne the use of his room so that he could rest. The doctor accepted. They had not exchanged a dozen words. When Arnaud, exhausted from combat, closed the door behind him, his bag hung from his shoulder like a dead hare.

Montefoschi first of all made it his business to snuff out every candle, for, he thought, darkness is best for the sick. And besides, he was anxious once again to be the one to decide. This is why he had fretted at being no more than a spectator, while the medicine man prepared his concoctions. In the greyness of the room, as darkness slowly descended, the presence of the two men was reduced to Vartan's even breathing and the violent throbbing of Montefoschi's heart. The Venetian pulled up a stool and sat at the bedside. With his hands joined and his knees together, this papal ambassador assumed the pose of the servant who in the past had watched over his mother in her sleep. Every evening saw the servant turn into a guardian of stone, ensconced in a chair drawn up at the bedside of Lucia Montefoschi, whose nights were thronged with nightmares. Lucia had woken with a start one spring morning at dawn, with a taste of ashes on her lips. She immediately flailed the air with her hands, called for help, uttered her servant's name, but the servant was lying on the ground, with blood trickling from her mouth. Lucia Montefoschi then regained the brisk movements of young girls and chambermaids. She mopped up the blood with a cloth, while praying for the salvation of this soul. For the first time ever, she touched the hair and cheeks of a dead woman. She rolled the soiled cloth into a ball and noticed that it was a sunny day. When her son was an adolescent, she described to him that strange dawn, with the pool of blood and the stiffening corpse. She told him the story after recounting her nightmares in which flocks of white birds whirled round. She spoke of their squawking and their wings enveloping her. She spoke also of her terror. From then on, whenever she presided over the Sunday meal in her husband's absence, the child saw her amid a swirl of feathers and bird cries, and recognized in her the anxieties that sometimes cast him on his bed, full of fear and perpetually overcome by visions of aggressive whiteness. She died at the beginning of a scorching hot month of May. Her

last wishes were respected: kitchen maids released handfuls of down feathers from her bedroom window. It snowed for a long time in the sunshine heralding summer.

At Vartan's bedside, grieving at this memory, Montefoschi wondered whether the future held in store for him the same fate as the servant whom Lucia had cherished, or whether he would end up, after an heroic struggle, being cut to pieces by a Mongol or a Persian.

It was like an oven in Montefoschi's bedroom, to which in fact Hovsep had retired. His thoughts were entirely centred on Arnaud de Roanne. While the doctor was busy at his task, he had the impression of standing on the threshold of a world previously unknown to him. It was the first time that he had ever felt for a single human being desire, fascination and love. While watching him, he had forgotten the trial in Ayas, the verdict, the executioner, and the punishment of which his body had since borne the evidence. But there was a moment when he became conscious that he was sitting beside Montefoschi and that some nights the Venetian indulged in sarcastic comments about a lover who would have brought no disgrace on a harem. To avoid giving way in the presence of Arnaud de Roanne to the hatred of Montefoschi that suddenly overcame him, he fled.

Hovsep was crushing between his palms little bits of a very flimsy wood that was black, like some charred object, and honeycombed, like a miniature wasps' nest. A granular dust escaped through his fingers and soon all that was left in the hollow of one hand was a tiny stick smelling strongly of dung which he began to suck. That was when the door opened and Arnaud appeared. Surprised to find someone already in the room, Arnaud then told Hovsep that Montefoschi had offered him his bed for the night. 'I always sleep here,' said the Armenian, 'but make yourself at home. It's a big room.'

Eager to be of service, Hovsep knelt in front of Arnaud to

untie his sandals, but the Frenchman did not appreciate having anyone act as a slave. He also refused to eat. He was overwhelmed with irrepressible weariness. These refusals upset Hovsep, who had a naive concept of love. That a willing submission might be looked on with disapproval was something he did not yet understand. But Arnaud's attitude of coldness towards him did not lead to any expression of resentment or reproach.

Hovsep kept moving back and forth. He spread a big red coverlet over the bed, swept the floor, picked up the clothes scattered here and there. Arnaud asked him to stop this fussing. More astonished than mortified, the Armenian's bustle turned to stillness and Arnaud thanked him for it, then ignored him. Wrapped in his blue silk cloak, he had no thought but for rest.

Hovsep stood there for a long time, rooted to the spot and open-mouthed. He was turned to stone, and his face a mask from which came the panting breath of a man no longer sure whether he is standing on the edge of a precipice or on the banks of a river's calm waters. He finally bent his knees and crawled over to one of the mats lying on the ground. He spent the night trying to peer through the dark for a glimpse of the wondrous sleeper. He dreaded the light of day and the predictable rebuffs from the man he already insisted on calling 'friend'. And the day dawned, violet, and soon red mingled with shining gold. A ray of light crept up to his mat. As he felt a slight burning of his ankles, he turned away from the bed bathed in radiant grey to examine the skin on his legs, on which the dirt formed little brownish encrustations. He began steadily picking off these flakes with his fingernail.

The courtyard of the caravanserai was already ringing with commands and shouts when Montefoschi called for the doctor. His voice immediately brought back to Hovsep the memory of those nights in which he had yielded beneath the carnal weight of a man who took him while insulting him,

with tenderness perhaps as lovers sometimes do, but also with words of humiliation. The same hatred as the day before surged through him, raging and unyielding.

Montefoschi continued to call out in a voice both authoritative and impatient. Despite this, Arnaud de Roanne did not wake. So Hovsep went over to him, and shook him by the shoulder, urging him to let the brightness of the sun take precedence over his dreams. Montefoschi was calling for him, he must go.

The Venetian had stayed awake all night long, watching over Vartan, who, during an interval in his somnolence, spoke of a flood that would drown Hell and Paradise, and maybe Purgatory. Obviously anxious to know whether the world was infinite, he kept questioning Montefoschi on this subject, and Montefoschi had to confess his inability to answer such a question. However, he promised to take him to those confines that even Alexander the Great had refused to cross, dreading to be sucked into a darkness that harboured gods more bloodthirsty than the gods of the barbarians. He also vowed that they would go together and see for themselves whether the emperor's dread was justified. Arnaud de Roanne came into the room the moment just as Vartan, with his eyelids closing on a miry landscape where bull-headed deities roamed, fell asleep.

While Arnaud seemed satisfied with the patient's condition, Montefoschi was more cautious, having spent the night listening to Vartan's raving about the flood and the world's vastness. The doctor lost his usual stolidness. He smiled and held forth at some length: young people yearn to face tempests, imagining scenes in which the tumult of the seas is matched by the fury of the winds; dreaming of carnage so as not to detect within themselves the smell of ashes with which they are already impregnated.

With a sad laugh succeeding his smile, Arnaud de Roanne

finally showed some sign of solicitude for Montefoschi, advising him to get a few hours' sleep. But the man tetchily denied any tiredness, preferring to question the doctor about the strange fee he had demanded the previous day.

'Indeed,' murmured Arnaud, 'I'm prepared to take an interest in works admired by the king of Lesser Armenia and his people.'

Arnaud spent the whole of one baking-hot afternoon studying the manuscripts illuminated by Vartan. The red of the draperies so lauded by his contemporaries did not win his admiration. However, he was impressed by the faces of the saints and the faithful gathered on the banks of the Jordan. This monk's almost devilish skill was capable of bringing foulness to the surface of the smoothest of faces. Every single biblical scene was steeped in an atmosphere of depravity. Arnaud had rubbed shoulders with the vain, the miserly, the deceitful, but he had never been able to discern this abyss of wickedness in their features. He was disturbed by the idea that each and every man could contain such darkness within him. Then, with the intention of trying to glimpse into the depths of men's hearts, he decided that he would share the life of a caravan on a long journey, hoping that close contact with human beings would reveal to him what the young painter had already managed to convey of their souls. He did not have to make enquiries or look very far, for confident that the doctor would amaze Kubilai with his skill and learning, and add to his own glory, that very evening Montefoschi invited him to join his party.

Montefoschi had a bed made up in Vartan's room, which he hardly ever left now, for the illuminator's recovery was slow. As for Arnaud de Roanne, he had established his quarters in one of the common rooms of the caravanserai. There he treated those afflicted with scrofula and herpes. He had a

succession of patients from sunrise to sunset. He never asked assistance of Joshua, who kept pestering him, trying to fathom the strength of his belief and the strength of his unbelief.

While the Jew of Erzincan did not complain of being excluded from the place where miracles were worked, he nevertheless recalled with longing the daily wonders he had witnessed in Byzantium and the nights when Arnaud and he would talk of the stars and the marvels of the universe. He lurked in his retreat amid hissing glass vessels. He, who alone could boast of having been this master's truest pupil, was consumed with grief. At all hours of the day and night he would sip unctuous syrups tasting of smoke and spring flowers, of mint or sage, contained in flasks with necks that were narrow, long, twisted. He would tip crystal spouts towards him and imbibe some sickly sweet potion. In response to this treatment his body rapidly swelled enormously. Under his skin and deep inside his organs each syrup turned to poison. Within a short time Joshua lay like an inflated water skin amid an untidy heap of cushions and cloaks. His flesh heaved like dead water and his skin turned yellow. Between sips he started conversing with God, questioning him about the temptation to commit suicide, about the rancour and resentment that lead men to the worst excesses. God kept thundering curses before retreating into a silence that Joshua railed against. Then Joshua would tilt to his lips the swan neck of a phial, greedily supping a liquor that glistened with every reflection produced by the light of day, and God sighed. After a month of this daily tippling, his skin burst from an accumulation of pus in his groin and armpits, releasing a viscous substance that stank of decaying flesh. His body had spoken: there is no recovery after being close to such a man and then being abandoned by him. Joshua died at the beginning of summer as Arnaud de Roanne arrived in Tabriz.

# IX

In Erzincan's central market Hovsep bought a ram, tied its feet together and hoisted it onto his shoulders. The thick-set muscly beast bleated as if a knife were sinking into its throat. He hit it on the muzzle several times. The bleating would be choked back only to resume even more loudly. The man staggered beneath this load of meat, wool and panic. Three lines barred his forehead, three lines that not even his torture in Ayas prison had managed to provoke. He made frenetic progress and the crowd opened up to let him pass, alarmed by this creature bound to an animal. As he went on his way he brought back to life for the inhabitants of the city ancient times when giants would fell women and children with their bare hands, when a Titan would devour his offspring, when fabulous creatures were born of flowers, rivers and forests. Matrons grumbled curses against him. He was subjected to insults and by a miracle escaped a hail of stones. He himself snorted his scorn for these onlookers with lynch-mob tendencies. Full of fury and determination, he panted for breath in a cloud of dust. He was a fine mare, he was a demon.

He was let through at the toll gate. They knew him there, for he had been fraternizing during the siesta with the soldiers and all the Mongol flunkeys. He was tolerated. He was also mocked for his ever lurching gait and the pompous language in which he vented his spleen on the beggars. A captain asked him if he was going to trade his ram for a whore. But deaf to the officer's irony, Hovsep continued on his way, advancing through the shadows. He hurried on and soon found himself outside the city walls. In front of him began the rippling expanse of fields and the greenness of the vines. The ram felt heavier and heavier and it bleating grew hoarse, turned into a deep wailing, that of a trapped animal.

He followed a narrow path that cut across a field. The dust was thicker here than in the heart of the city. A bed of reeds extended beyond the field down to the Karasu. Waders glided over the water. Hovsep stopped on a little sandy beach. With a strong jerk he hugged the ram's legs to his chest, twisting them till they broke. The animal gave a cry and with a sudden wriggle bit Hovsep on the cheek. It was a serious wound. The man swore and let go of his victim, which rolled to the ground. Then he tore off a branch and used it to lash the beast that lay on its side, shuddering with terror. When the fleece was reduced to no more than red welts, he ceased his thrashing. Then his whole body slackened. He dropped down beside the ram and sobbed.

The river flowed by majestically, the colour of rust, and Hovsep was thirsty. But he made no move towards the water; he automatically felt the wound on his cheek. He drew his index finger between the lips of the wound and licked it. The blood had a taste of metal. When he stood up, it was to strip naked. He draped his clothes over the branches of the stunted trees growing there, like hides hung out to dry. The animal whined. The man spread its thighs open and lay down. He felt the ram's testicles beneath him. Then he rose and knelt in front of the ram. He castrated it with his knife and pressed the animal's balls to his groin. And he prayed for an improbable grafting.

The child came upon him, naked and spreadeagled over the beast. The boy was carrying a torch. His mind wandering in some other place where hope was fanned by madness, Hovsep had not heard the rustling of leaves nor the crunching of the sand. He drew himself away from the animal moistness when the child cried out. It was as though he were extracting himself from a bog. Shame and despair overcame him, for the look in a little boy's eyes, at first frightened and then derisive, brought home to him his destitution and his powerlessness to escape it. And this young lad, he said to himself, has the same

response as honest folk confronted with a monster. He became the victim of an hallucination: a crack opened up in the ground, the crevice widened, a chasm lay between him and the boy. In a seizure of panic, his hand opened, and the genitals fell at his feet.

The child had already seen men without their clothes on; his father, an uncle, his cousins when they bathed in the Karasu. They fought good-naturedly, they challenged each other to swimming races, or splashed each other with water. He envied them. But the man standing two paces in front of him looked wild, ugly, and bewildered. On his guard and at the same time fascinated by this blood-stained, mud-encrusted man, he noted the thick torso, the wide hips, this tall, slightly fat, spasmodically twitching body. Galled by this examination, Hovsep stepped over the gulf that, he believed, had opened up between them, grabbed the child by the elbow and seized the burning brand, without even wondering why a child was going about with a torch in the late-afternoon sunlight. He told the boy to be off, while holding him captive by his arms, as if undecided between forgiveness and punishment. The child braced himself, managed to escape the man's clutches and fled into the undergrowth. Hovsep was then left alone and disorientated. He saw the genitals, ground them with his heel, stared at the river and the birds flying over it. For a few moments he gave way to despair, then planted the torch in the sand and got dressed again.

He was buckling his belt when someone hailed him. 'Hey!' a voice called from a thicket. Hovsep turned round and recognized the child who repeated several times with a derisive laugh, 'Hey! Hey!', and finally hollered, 'Ball-less! Hey! Ball-less!' He sprang towards the child; the child ran off.

In the falling darkness Hovsep pushed his way through the branches, tore his clothes on brambles. His arms laid about him as though equipped with bill hooks. And he too hurled insults. He ran on till he came to a field. The town glowed red

in the distance. The child's silhouette zigzagged through the vines and was soon no more than a faint shadow that would blend into the crowd in Erzincan. The man gave up trying to chase him. He cursed him, but without conviction. He turned back, then skirted the hostile wood that he had just come through, now advancing cautiously over muddy ground, avoiding ruts and roots entwining the entire surface of a dubious path. He finally emerged onto the beach where the torch was still burning. He thought of building a bonfire. Once the animal was burned to ashes, he would daub himself with the hot grey dust which would be all that remained of his sacrificial victim. But he confined himself to passing the flame over the fleece. The ram did not react to this tongue of fire: it was dead. Yet its belly rose with regularity. Rats had begun eating into its anus and were having a feast. Hovsep vomited. With a torch in his hand, stooped and gagging, he looked like a hero suddenly taken ill.

He had moved away from the carcass and was sitting a few paces from the Karasu from which rose a muddy coolness. The river, bluey-green here, silvery there, made straws and strands of grass twirl, reflected the splendour of the sky and the trails of a big ragged cloud. Boats floated downstream like phantom islands. Silence extended over the nocturnal shimmerings. Even the busyness of the rodents was no longer perceptible. Hovsep's mind wandered back to his past.

He had roamed the towns and countryside of Lesser Armenia and for months led a hermit's life in the mountains. He had bled hares the way the fox bleeds them, smothered a cock after getting into a chicken coop by moonlight, entered farmyards in broad daylight, and tempted fate, for he liked to steal an axe or a bill hook from under the nose of its owner. He stole fruit from orchards and coins from bedrooms, and contrived to have the peasant catch him in the act; he would then kill the witness to his theft. But Hovsep had tired of tracts

of corn and fields of cotton. So he turned his back on the farms and villages to go wandering the streets of port cities where the sight of boats bristling with masts and decked with coloured flags never palled. He learned to distinguish the ensigns of the Genoese from those of the Venetians, Arab merchants from Persian, and the scent of amber from that of nard. At Ayas he perfected his thieving techniques. It was a small bag of pearls that brought about his downfall. The diamond dealer caught him just as he was stuffing the canvas pouch inside his shirt. In prison he developed a distaste for all forms of carnal promiscuity. After several days of observing clan rivalries and being taunted for having declared with pride that he was a virgin, he was taken into a room where he thought his end was near. But no, his head did not roll from any executioner's block. Nevertheless, the penalty was far from lenient: he was condemned to be castrated, and was immediately handed over to the agent of justice. Among those who witnessed the penalty being administered was that close relative of the king, Hagop Karagueuzian. This man approved of heavy sentences and of the punishment of habitual thieves and pimps. The blood and screams of the punished had never affected him before that day. But he felt unaccountably sorry for this thief, took him to Sis and presented him to his wife Mariam. For three years Hovsep lived in a huge residence where his duties consisted of preparing arcane potions, grinding almonds, massaging a woman's body with floral essences and fanning it on very hot sunny afternoons. At night, seated naked, cross-legged on his bed, he would place a broken piece of mirror between his thighs and examine the scar's purple swelling. He who had never experienced the slightest sexual desire in the days of his criminal activities, now started to regret not having been more susceptible to the beauty of sailors or prostitutes. And, immured in his regrets, he stroked the wretched mark of his martyred flesh.

In that palace at Sis the eunuch began spying on the love

affairs that flourished and died around him, to follow the progress of jealousy in a face's features and to reflect on the thoughtless deeds that lead to a lover's betrayal. Surrounded by her friends, his mistress would urge him to recount the wandering life he had led in Lesser Armenia. He revealed a talent for transforming the banal episodes of his career as a thief into a colourful epic.

One morning Hagop Karagueuzian suffered fits of breathlessness. By midday he was dead. Hovsep was unable to analyse the ambiguous feelings he experienced at the demise of his protector. By taking him under his roof, he had saved him from the torments that people inflict on emasculated thieves, but the eunuch secretly blamed his protector for having failed to shorten a life that was for evermore to be denied the simple pleasure of sexual enjoyment. And yet he had grown fond of a man who every day had treated him with great benevolence, with inexplicable kindness.

Mariam Karagueuzian's conduct was that of a resourceful widow, determined to govern her patrimony as absolute mistress. Once a month she visited her warehouses in Ayas. She made inventories of the casks and stocks of spices, sold furs in order to buy incense, nutmeg or silk. While she immersed herself in a world of trading and bargaining of all kinds, Hovsep was off duty. It was while idling on a quayside in that town that he met Montefoschi. From the exchange of a few words a rapport was established between them which both wanted to continue, explore, intensify. They agreed to see each other again and met often in the city of Sis as well as the city of Ayas. Montefoschi would hold forth and fire Hovsep's imagination with his talk. At the names of the countries that his friend mentioned, Hovsep dreamed of red deserts and roads winding through jungles and marshes. Aware of the influence he had over this youth, and amused by the delight he brought with his tales of blind princes and kings more revered than gods, Montefoschi shared his own ambitions and persuaded Hovsep

to follow him to lands where the conquest of riches was assured. He treated him with the respect an emperor shows to his minister and included him in his plan to return to China under the patronage of the Pope and the Armenian monarch.

The river was black and yet glazed with silver in the middle. It rustled like foliage and gleamed like a fox's coat. Growlings alerted Hovsep to danger. Animals were fighting over the ram's meaty remains. While some shadows darted round a pile of bones and flesh, others in their stillness looked like lean gods. The former invested their every movement with a smell of putrefaction. These famished and baying shadows fought among themselves, rapaciously took bites at each other, chased each other and always came back to the gradually torn-apart ram. Hovsep watched the beasts' violent activity. The shadows scented the man's presence. They abandoned to their females and offspring the pleasure of foraging in that belly. At their approach he recognized them as the wild dogs that in packs could play as much havoc with herds and flocks as wolves. Plaintive, shrill or harsh yapping disturbed the lovely summer peacefulness embodied by the sky, the reed bed and the river. He slowly rose to his feet, waved the torch in front of him, tracing a circle of fire in the air. Without haste and holding his breath, he backed towards the river. The dogs tried several times to bite him, but there was always a flame at their throats or eyes. And they would turn tail, yelping, then come heading again towards the water where the man stood wielding a flaming brand. He struck them with it and the bank now smelt of scorched fur and animal sweat. They had all deserted the sandy area where nothing was left of the ram but bones and scraps of wool. Suddenly the dogs stopped advancing on him. They sat on their haunches and stared at Hovsep who plunged into the splendidly calm river. They looked like a freize of Cerberuses waiting for their escaped prey to drown.

For a long time the man waded alongside the riverbank.

The coldness of the water seized his muscles and obliterated his thoughts. The torch grew heavy on his arm. There was a bend in the river and the town came into view, a solid mass of stone that dispelled the dark with all its whiteness. In a hour dawn would tinge its ramparts blue. Hovsep lowered the torch whose wavering flame caused the reflections of the Karasu's gentle waves to fissure. Faces, landscapes and beasts rose from the depths of the shifting shadows, among the thousand platinum wavelets. Then he was stricken with terror. In a gesture of panic he held the torch aloft so as to stop seeing on the surface of the water the tangled hair of men and women, the jumble of horses and laurel bushes, roses, eagles, Montefoschi and Vartan, Hagop Karagueuzian and the castrator. A past life rammed his sides, enveloped the lower part of his body, splashed and caught him in its tentacles. In the frenzy of his movements he was like a wild cat caught in a net. He told himself that it was the cold and the memory of the dogs that created such hallucinations in him. To drive them away, he thrust the torch into the river and so put an end to these visions of the living and the dead. Then he made for the bank, collapsed on the hard ground and surrendered to sleep.

# X

Informed by his flock that there was an Armenian monk staying in the town, who was ill and being treated by a sybarite of the worst repute, the bishop of Erzincan sought an interview with Vartan. An appointment was made and throughout the conversation Montefoschi stood guard at the bedroom door, with his hand on the pommel of his dagger, and with an expression in his eyes that was more vacant than indecipherable. The bishop was left thoughtful by the conversation, which he cut short, having no desire to be expansive within the Venetian's hearing. However, Montefoschi was not in the least curious about what was said between Vartan and the prelate, nor about the conclusions either of them had drawn from their exchanges. That very evening the bishop sat down at his desk and wrote a letter to Hethum II. In it he expressed his doubts with regard to Vartan's faith, describing him as a youth exhausted by a strange illness and subject to the influence of both an unscrupulous Venetian and a charlatan. He drew particular attention to Arnaud de Roanne with a few scathing remarks that would have spelled the ruin of anyone's good reputation. In the words of the bishop, the doctor was cast of a bronze of Luçiferian properties. He took the liberty of advising the king to organize a second mission and to forget the first, since Vartan would never be capable of shaking the beliefs of the barbarians ruled over by Kubilai. Vartan was nothing but a compound of incredulity and moral weakness. Having signed his letter, he felt free to act as he saw fit.

The bishop of Erzincan had a court made up of priests and adolescents whom he harangued every week. He pitted them against the cynics who dared to turn aside from the cross. These fanatics demonstrated as much ease in wielding a knife as in studying sacred texts. He painted a portrait of Arnaud de

Roanne that appalled these souls taught to pass judgement and made them certain of the necessity to dispatch such a disgraceful doctor to hell.

When ulcers covered Vartan's neck and back, Arnaud told his patient that his recovery was near. He took him to a hot spring with healing waters. Immersed in the stifling vapours, Vartan was elated at the idea that before long he would be getting back to the riotous life that he wanted to lead. The day after his steaming-hot bath with curative effects the ulcers did indeed dry up, as the doctor had predicted. Although Vartan praised the talent of the doctor to anyone who would listen, he did not seek to foster the birth of a friendship. This discounting, even spurning of any closer relationship arose from the unease he felt in Arnaud's company, for the doctor sometimes scrutinized him like some inquisitor hoping to discover a secret. So he avoided him and felt better for it. What neither of them knew was that some of the dreams they were having were identical. One of these, the most recurrent, had them falling into a chasm with piles of snow-covered rocks lying at the bottom. A sun smaller than a pomegranate was lodged within their breast, slowly consuming them. Vartan declined to interpret the dream whereas Arnaud never tired of questioning every image, even if the result of his decipherings always dissatisfied him. Any explanation seemed crude. He came to distrust his intuition which he had thought infallible and to deride his intelligence which he now told himself he had overestimated. Following the logic of this belittlement of his faculties, he attributed the cures – of which he had after all been the agent – to chance, and no longer to his advanced knowledge. He hated himself for faults he had never had: arrogance, deceitfulness, vanity. One morning he closed his door to the sick and the scrofulous, and before the crowd queuing for a medical consultation he emptied the contents of his phials over a lemon tree in the courtyard of

the caravanserai. That was the day an old man called him Arnaud the Wicked.

Vartan was still subject to sudden bouts of weakness. The doctor declared himself unable to prevent with some suitable medication these dizzy spells followed by fainting. To spare Vartan any fatigue, Montefoschi laid at his disposal a covered litter, lined with velvet and filled with cushions. Vartan did not take exception to the idea of installing himself on a transportable bed, used only by women in Lesser Armenia. The regular swaying of such a means of transport perfectly suited his present mood. He enjoyed this indolence and relished the hours of idleness his convalescent status afforded him. The wooden-framed silk-draped palanquin attracted attention and distinguished this caravan among austere processions of camels, horses and men.

Arnaud de Roanne was saddling his mount when a man bumped into him, who apologized for his clumsiness and slipped away into the tumult that characterized a day of departure. When it happened, Arnaud had felt a cold pain in his shoulder that still persisted. So he stripped to the waist and found a tiny scratch reddened with beads of blood. He collected a drop on his finger. He was convinced that everyone's blood had a particular taste. There was blood that was bitter, sweet, or peppery. The insipidness attributed to this liquid was due only to most people's poor sense of taste. The blood of those afflicted with goitre was not in any way comparable with the blood of the incontinent or sufferers of gout, nor soldiers' blood with the blood of fat women. His own defied all analysis. It had a vague flavour perhaps of rusted steel, of damp straw or cloth. But in any case what difference did it make! Since he now doubted the effectiveness of his drugs, he did not take any of the medicine that purified the blood. He smashed against a rock the flask containing an infusion of the sovereign antidote to any poison, and hoisted himself on to his horse.

# XI

The route from Erzincan to Ercis took them across the unchanging landscape of the plains. Flocks of sheep eddied across the tufted grass in slow tides. The caravan did not make the long detour that would have taken it to Mount Ararat and Vartan's justifiable curiosity about the birthplace of his ancestors was not satisfied. Montefoschi had made it clear to him that visiting the area around Ararat would delay their crossing of the Pamirs which absolutely had to be made before winter. Moreover, visiting a place that legends and old folks' memories had from early childhood made dear to one's heart was not to be recommended, in order to avoid the excessive excitement that undermines the vigilance necessary when travelling. 'You cannot imagine how cold it gets in the Pamirs,' added Montefoschi to discourage Vartan once and for all from casting his glance towards the ancient kingdom of the Urartians. Behind the draperies of his litter the young man imagined the celebrated Ark as a big black thing presiding over the memory of vanished civilizations, like an eye filled with irony surveying men and their need to wage war. He also pictured it as a sovereign and indestructible mass swathed in mists. It was like a sea monster beached on top of a gigantic rock. Vartan fell in with Montefoschi's decision, and he now hoped to spend the winter in the Pamirs and, no matter what, to have some extremely intense experiences.

At every stopover in the caravanserai Hovsep continued to share Montefoschi's room. He submitted to his lover's advances and caresses with chilling detachment. It was during their nights of stormy passion – rendered so by the increasing ardour of the man's feelings towards him – that he strove at last to verse himself in the arts of love so as to practise them later in Arnaud de Roanne's bed. But there were nights that

resounded only with the snoring of Montefoschi, overcome
by the weariness of travelling. On those nights Hovsep left
that quasi-conjugal bed for the courtyard of the caravanserai.
There he pounded herbs and roots in a mortar or mixed drugs
in a jar. He toiled away like an apothecary without noticing
that sometimes, wakened by his absence, the other observed
him. Of course, the Venetian considered the possibility that a
relationship had developed between his lover and the doctor,
but this conjecture did not yet instil in him the least jealousy.
He simply told himself that Arnaud had given way to one of
Hovsep's crazy ideas out of kindness. He knew the eunuch
was envious. So it was likely that he should conceive a desire
to rival the doctor one day in the concoction of potions. This
idea then elicited a cruel smile from Montefoschi; he thought
his friend ridiculous.

Hovsep had a draper in Ercis make him a cloak of garnet-red
silk, cut just like Arnaud's, for he imitated Arnaud in every-
thing. He affected a slow, suave way of speaking, used a refined
vocabulary, vaunted an age-old wisdom. And in shops and on
the streets, he would flounce the folds of his cloak, as though
in boredom. Swirls of fiery red responded to swirls of sapphire
blue when the two men walked through town or presided
with Montefoschi over a meeting of merchants. But Arnaud
de Roanne constantly obliged him to replace old habits with
new ones. Since leaving Erzincan, he no longer treated the
sick and the dying, and no longer prepared medicinal draughts.
Hovsep too abandoned salves and ointments. Arnaud grad-
ually retreated into anonymity, which is what he wanted. He
craved this status the better to observe the world without
being importuned at every moment by the sick. Besides, he
knew that this desire would soon be fulfilled, his renown as a
doctor not having reached the cities of Asia. He divested him-
self of his cloak at a rag dealer's shop and received in exchange
a handful of copper shot that would be of no use to him

whatsoever. He was being robbed, but he did not care. Following Arnaud's example, Hovsep parted with his cloak without seeking to gain from its value. Only the joy of behaving alike was of any significance. He was content merely to be the shadow of a man now suddenly so ordinary-looking. Yet he was more easily noticeable than Arnaud, because he walked with his mouth open and his arms crossed on his chest. When they were out together on their own, Arnaud called him Fly-catcher, even as he wondered why he tolerated his presence. But he reminded himself that he had vowed to study in depth every human face. And Hovsep proved to be a good subject for observation. In fact, in Arnaud's company, he seemed to wear a perpetual look of admiration for him. Yet anxiety, fear and despair were sometimes detectable beneath this mask.

Arnaud was a stranger to inactivity, having for a long time been accustomed to prepare his endlessly time-consuming medicinal compounds. For this reason he could not keep still, and so went exploring Ercis in every direction. Within a few hours there was nothing he did not know about the customs of the people, the specialties of local craftsmen, the crops that were grown. He made his way among the bee hives, or consulted a bestiary at the house of someone he had met by chance. He was here, there and everywhere, always on the move. All that he retained of his scholarly past was an indomitable energy. Everything provoked his interest: facades scorched by the sun and the gleam of daylight on gravel, exhausted beasts of burden and pasturing sheep, women plucking a fowl or stirring broth. In Arnaud de Roanne's company, the least village became a labyrinth, every trifling incident was endowed with significance.

One afternoon in Ercis a man with a muffled voice accosted him. Acting in a conspiratorial manner, the stranger made a proposal that astonished and disturbed him, and left him perplexed. The man urged on him pleasures that he had long scorned, for he had been obliged to turn away from

temptations of the flesh the better to devote himself to his researches. In short, his ignorance and withdrawal from matters of love barely distinguished him from a monk. But since he had become disdainful of teaching and practising the art of healing, he was often eyeing up women. The pimp had no doubt resolved to speak to him after noticing the eloquent glances he cast at female passers-by. Arnaud made as if to gather the folds of his cloak around him, but he remembered that he had sold it. He felt defenceless in the face of this offer, and in the end nodded his head in acceptance.

As usual, Hovsep was standing a few paces away. Without discerning the words in detail, he caught the drift of the conversation. It was utterly unbearable for him to imagine Arnaud with a woman, and he was having none of it. Without thinking, he violently pushed aside the man, who, in instinctive self-defence, whirled a whip whose handle completely disappeared in his hand, a whip that could have been a child's toy. Hovsep felt for his dagger. The man laughed. Then Arnaud intervened and calmed them down.

When he saw the doctor going off with the mysterious stranger, Hovsep went rushing after them, telling himself that he too was prepared to romp in bed with a whore.

Hovsep was not qualified to judge the beauty or ugliness of the girls sauntering about in the brothel's huge salon. Their near nakedness embarrassed him. He would have paid a magician a fortune – one that he did not have – to be taken back to the days of his banditry, to his adolescence when his only desire was the desire for spilled blood, when his fate was not sealed by a doctor who took less notice of him than of his own shadow. But a miracle of this kind would never happen. Crazed men wanting to escape some torment or the abounding dangers of reality had never obtained anything from sorcerers but a momentary trip to the land of oblivion.

★

When Hovsep ended up in a bedroom with the girl assigned to him, he would not let her touch him. All the same, she invited him to come and lie down. He did not respond. She closed her eyes and appeared to be asleep. But she was only pretending, for he heard her repeat the invitation in a clear voice. He then told her that he was afflicted with a disease that ruled out any form of intimacy. At this admission she gave an enigmatic smile. He felt strangely calm in her company, and told her so. She seemed not to be listening. This sense of calm did not last. Murmurs could be heard coming from the next room, which immediately put Hovsep on his guard. The girl slipped out of bed, went over to the dividing wall and showed him where a grilled peephole had been cut into it.

Hovsep was thus able to observe the writhings of two naked bodies. As he watched their antics, a hand clamped his genitals. He turned and struck the girl. She screamed when he hit her a second time. She was still screaming when the bedroom door opened and Hovsep was grabbed by the shoulders and thrown out on the street, like the undesirable that he was.

At the first shrill cries that resounded through the brothel, Arnaud's temporary companion shoved aside the body that was fornicating with her. She leapt to the end of the bed, covered herself with a sheet and rushed out into the corridor never to reappear. Left lying alone, Arnaud de Roanne cursed the curiosity of women and the uproar that had dared to interrupt this unprecedented and still unconsummated act, whose repetition in a stable, or under a tent, or in a room identical to this was now what mattered most of all to him. His diffidence as a virgin preliminary to this act was eventually to give way to the brutality of an old trooper. A face no matter how beautiful would be less attractive to him than a body available for sex. The dampness of the sheets encouraged carnal thoughts.

The mysterious man burst into the room and told him of Hovsep's outrageous behaviour. Spitting out curses with dramatic virulence, he advised him to choose his friends or servants more carefully in future. He was not one to stand on ceremony. The fellow was beside himself, and physically drove Arnaud de Roanne out of the bedroom.

And it was with angry shouting and jeering following him into the street that Arnaud left the brothel. Hovsep was hunched up, waiting for him. At the sight of that cowed figure already entirely submissive to the punishment that must surely come, Arnaud experienced a sense of disgust. This was a feeling he had never had before. For the first time too he felt vengeful. But he refused to break the bones of a man now shaking and trembling, for he had decided to play the part of one who shows indulgence rather than rancour. He put his arm round Hovsep, assuring him that he held nothing against him for the trouble he had caused within the walls of a house he was sorry to have entered. Back at the caravanserai, Arnaud washed Hovsep's swollen face and stuck a plaster on it that would rapidly dispel the bruises. This solicitous care amazed the eunuch who accepted it as a gift and a sign of friendship – a friendship finally daring to declare itself.

# XII

There was a town halfway between Ercis and Tabriz that an earthquake in the early years of the fourteenth century was later to obliterate. In this town that was proud of its markets and orchards, Montefoschi was obliged to extend what he had planned as a brief stopover: several of the travellers had dysentery.

Faced with the swords and bows of Hethum's soldiers, the inhabitants gave up the idea of driving beyond their walls the listless men who emanated a stench such as they had only been afforded the opportunity to smell by the promixity of animal carcasses.

Immovable in his decisions, Arnaud de Roanne turned away a delegation of merchants who asked him to treat with some drug those of them who were afflicted with diarrhoea. He denied having any competence to deal with the matter. He was accused of being cruel and heartless. Montefoschi saved him from lynching by citing an illness that was destroying the proper functioning of his mind. He was taken at his word, and the incident was closed. But during a stormy private exchange with Arnaud, the Venetian rebuked him for his selfish irresponsibility. Though it did not come easily to him to drop his reserve, the doctor then tried to explain an attitude that he recognized as reprehensible. The Venetian dismissed with an exasperated gesture the reasons for this behaviour that was nothing short of incomprehensible. He compared him to a guard guilty of failing to keep watch, and threatened to punish him with the pillory if he persisted in denying his talents as a doctor. Arnaud reacted with lofty restraint, thanking him for his protection against the merchants' fury by his statement of the truth: his mind was indeed atrophying day by day and his memory was no more than an empty container.

Lastly he added that he needed to rest. Aghast at this calm admission, Montefoschi apologized for his outburst and left the room.

No matter where he roamed, Arnaud always ended up outside a certain house. Its portals, of smooth reddish-brown wood panels opened at all hours to servants loaded with baskets. Behind this monumental austerity, the bustle of cooks and valets, the owners' serenity and the unruliness of the dogs came together in a symphony of marketplace clamour. The fascination that this house held for Arnaud was linked with death. He pictured himself as the sovereign lord of a great many servants and a bevy of women attentive to his every movement and his slightest whim. He would have enough authority to rule each moment of an everyday life untroubled by any kind of personal disquiet. Amid the luxurious tedium of his days he would wisely grow inured to the idea of finally having to shut his eyes to his wife's beauty. He would acquire that proud indifference to all luxury and pleasure of whose pursuance and attainment he had read in the texts of the Ancients. But beneath a harsh sun in the countryside of Castille, he had had an intimation that he would never reach old age.

The inhabitants of this house were the last to leave the ill-fated town. Birdsong and squawking came from an inner courtyard. One night Arnaud scaled a wall that was crumbling away in many places. He landed in the yard which had a pond in the middle of it, and a cage in one corner. He was greeted with cluckings and the flapping of wings. Arnaud dusted down his clothes with the back of his hand. This gesture, which was not at all overenthusiastic, nonetheless panicked the birds locked inside the cage. As the bars prohibited flight, they resorted to a frenzied dance. Those distinguished hunters the Khazars having taught him their decoying skills, Arnaud cooed. This trick had the desired effect: at the very first notes of his song, the tumult ceased.

Arnaud inspected the reception rooms and bedrooms, the kitchens and cellars. Then he stripped the beds and sofas of the soft silky textiles with which they were covered, and with this bundle in his arms he returned to the cage. At his approach the clamour resumed. He draped the sumptuous fabrics over the wicker frame. A gold and purple darkness brought the birds back to their perch.

This time Arnaud preferred to use the gate rather than climb the wall. The lock offered little resistance to the pressure of a knife blade. He left the door ajar. In any case the house would be safe from looting, since the Armenian militia, on Montefoschi's orders, patrolled the streets every night to discourage thieves.

Strangely the town had no caravanserai. The merchants were lodged in stables or sheepfolds. Hovsep had claimed one of these. A dry cough and a persistent fever kept him in bed for two days. Arnaud made up an improvised bed for him, with a mattress of straw, boxed in with piles of leafy branches. Hovsep spent the whole time in this nest. Arnaud assured him that the sap still contained in freshly cut wood freshened the most fetid atmosphere. Framed in an overhead window, the sky, by turns blue, fleecy white, or inky-black, conveyed to the sick man the passage of time.

This sylvan environment had a salutary effect. The fever passed and the coughing fits became less frequent. Now this body that had for too long lain languishing in the straw needed some exercise. One evening Arnaud suggested a walk. He led Hovsep on a haphazard route through the streets to the house with the birds. Before crossing the threshold, he announced that he had prepared a surprise for him, and to make it a complete surprise he had to blindfold him.

He pushed his blindfolded companion over to the cage, and at once pulled off the shimmering fabrics. He opened the latch and shoved Hovsep inside. The moment he was imprisoned in

the wicker cell, the convalescent tore off his blindfold. Brought down on his knees by the shove he had been given, he realized what kind of trap had been laid for him. Moved by the solicitude with which his friend had been caring for him, one evening in a mood of trust he had disclosed a list of his virtues and vices, his fads and phobias. Of the latter the most distressing was his obsessional terror of birds. And now birds were brushing against him, sweeping down on him with panic, fury, frenzy. He spun round, threw himself to left and right to dodge these flurries of wings. Wing feathers and tail feathers cut like scythes, and these weapons, no less rigid than silky, scored his body with stinging slashes. A wild animal overcome by the number of assailants, he was now crawling on the ground. The crazed circling of the birds accelerated. Flailing to defend himself, Hovsep scratched a bird's crop with his nails, and animal blood mingled with that of the man. Finally exhausted by his struggle, he clung to the bars, stock still, like a hostage awaiting execution. The throng's frantic aggression then subsided. That was the moment Arnaud chose to open the door of the cage. One by one, then in a flustered confusion, the birds flew off towards the boundary wall. After which, they rose silently in a luminous cloud up into the night sky.

Arnaud dragged Hovsep's long wounded body to the edge of the pond. His vengeance satisfied, the memory of the incident that had taken place in the brothel at Ercis dimmed. And it seemed to him despicable to have succumbed to a feeling that was crass, to say the least. Slowly Hovsep emerged from the nightmare in which Arnaud de Roanne had plunged him. He refused to let the other help him to his feet. Suffering an agonizing thirst, he descended the three steps into the pond and drank from his cupped hands water that tasted stagnant. He cleaned his wounds himself. Standing in the small basin of grey stone, Hovsep stripped naked and revealed to Arnaud's gaze the evidence of his mutilation.

## XIII

At every stopover Vartan sought relief from the inactivity and boredom to which travelling in a litter constrained him, by roaming the streets of opulent cities or towns. The right to inertia that he had established at Erzincan had been the expression of only a passing mood. On several occasions in Ercis he ran into the unlikely couple formed by Arnaud and Hovsep. The brevity of these encounters had not afforded him any inkling of the coldness one always showed to the other and the submissiveness, bordering on madness, of the latter towards the former. But he took the liberty of making assumptions based on the amazing spectacle of the doctor with the unsavoury Armenian always hard on his heels. He suspected them, among other things, of being associates in some shady business dealings that led them to the retreat of some forger or receiver of stolen goods. In the small town where some of the travellers were hastily buried, these partners in crime again chanced to cross his path. This time Hovsep was no longer trailing behind Arnaud. They walked side by side, chatting. Vartan followed them. They turned off the broad avenue into a narrow street, and off the narrow street into a shady orchard. Their conversation gradually gave way to a conspiratorial silence. Vartan followed them until they returned to the streets and Arnaud parted from his companion. The closeness to which their companionable stroll testified galled him and he envied this mysterious friendship. It reminded him, wrongly, of the intimacy between his father and the serving girl. A devil prompted him to destroy its existence. He reported back to Montefoschi as a spy. He distorted the significance of gestures, invented a relationship that supposedly began at Erzincan. He had a host of anecdotes casting light on Hovsep's duplicity and Arnaud's depravity.

These revelations devastated the Venetian. When Vartan left the room, the man he turned his back on was full of fury and henceforth consumed with a morbid jealousy. But the next day Montefoschi showed no sign of the resentment and madness that were to reduce to ashes his ambitions and dreams of glory.

After another two days had dawned the sick had recovered. The caravan set off and travelled away from a town festering in a pestilential stench. For the merchants it remained for ever a place ruled by evil spirits whose breath, like a noxious wind, poisoned the air and penetrated one's entrails. Although raised in the Christian faith, Montefoschi from his earliest excursions into foreign lands had constantly made a mockery of his religious precepts. He left offerings at the foot of statues of gods of whose teachings he knew nothing. Before taking leave of the town from which only groans were to be heard, and where a dismal calm had descended on the streets and houses, he poured a bowl of honey on to the straw in a stable, so that the spirits might revel in its fragrance.

# XIV

The street stalls in the markets of Tabriz were piled high with rolls of silk, cotton and taffetta, and offered amber and musk for sale. The darkness of shop interiors gleamed and glistened with the milky-whiteness of pearls and the green of emeralds. Since the sack of Baghdad by the Mongols, Tabriz had claimed the status of Persia's trading capital. Nestorians and Jacobites mixed with each other without hostility. But the iconoclastic faith of the Moslems pitted its fanatics against the crazed devotees of a crucified god risen from the dead. Religious wars loomed on the horizon.

At Tabriz, Montefoschi and most of the merchants were to part company. Only the most adventurous of them would continue eastwards, towards deserts described as the mouth of Hell, the snows of the Pamirs, and princely courts where, rumour had it, the women resorted to magic to detain the brutish men that came from France or Italy. So they would journey on with Montefoschi, following routes through a world that even the Arab cartographers had not mapped. The Venetian's innate authority and his familiarity with these uncharted lands that he prided himself on having already traversed were a warranty of the success of this enterprise, the mere idea of which appalled the faint-hearted and those that scorned an inscrutable and manifold universe. However, his fellow travellers had a low opinion of Hovsep and his bragging, of Montefoschi and his boorish tastes, and of Arnaud de Roanne and his aloofness which they associated with treachery, but it was their hope that these three individuals, who had been chosen to communicate to barbarians the greatness of a civilization, would enable them, dead or alive, to become part of a legend. They would be witness

to three destinies every segment of whose trajectory would blaze like the sun.

In the town of Tabriz there lived a Greek who had long retired from trading. By his assiduous cultivation of the influential bankers of Persia, he saw his capital yield a regular profit. But he did not spend his whole time engaged in financial dealings. Marcos Traboukis considered himself something of a philosopher and theologian. Men of thought and wisdom taught him about the purification rituals of brahmins and explained the abnegation of all things to which Epictetus devoted his life. In the shade of his garden, Zoroastrians spoke metaphorically of the subterranean city built by Afrasiyab in ancient times; and priests wearing a cross on their chest endlessly retold the events marking Christ's brief existence. While listening to these men, Marcos took pride in being able to surround himself with representatives of every religion and converse with them as Kubilai did.

When Traboukis was once on a trip to Georgia, a man treated and saved his horse after its hock was bitten by dogs. That man was Arnaud de Roanne. They became friends. In a village inn they exchanged with each other the fruits of their experience, bringing their different areas of knowledge to bear in their verbal sparring; the Greek amused his friend by introducing him to the wiles of merchants; Arnaud de Roanne remembered hundreds of spells from sorcerers' manuals for treating sheep with the staggers. Passing from generalities and instructive comments on their respective activities, they ended up revealing their secrets. And as they continued to exchange secrets, they decided to travel on together as far as the eastern borders of Persia. There they parted company, for Arnaud had to head north to see for himself mares that sweated copious quantities of blood, and to gather from the Naryn Valley some blue flowers that would only germinate in

wolf droppings, while Traboukis returned to Persia to select a wife.

Marcos's vast residence stood not far from the pepper market. Its boundary walls were balmy with spices. Anyone walking by was transported, by the fragrant smells emanating from those stone walls, to the most distant countries, described only in fairy-tales. Marcos spent long hours dozing in the afternoons, and his flowers, trees and fountains gave brilliant colour to his reverie.

As soon as he arrived in Tabriz, Arnaud, accompanied by Hovsep, paid a visit to his friend. They had not met again since bidding each other farewell on a blindingly-dusty yellow track. Their reunion was marked with pleasure at the fulfilment of a hope. They drank white wine from Shiraz, and ate rice with berberis, stuffed quince, and a terrine of pickled fruit preserve. Marcos Traboukis's wife withdrew to her own apartments as soon as the old friends began their celebratory feast. Marcos complained of having no heir. It was a constant sorrow that made him consider his wealth of little importance. There were mornings when he was overwhelmed by the futility of things. Doctors had examined Erietta and found nothing to prevent her giving birth. An astrologist had drawn up her horoscope. What emerged from his decipherment of the influences of the heavenly bodies was the paradigm of an unambiguously maternal nature. The conjunction of the planets promised her a home complete with cradle. But a fortune-teller had also seen a phantom at Marcos's side. His interpretation of this macabre presence concluded that the master of the house was incapable of laying the first stone of any dynasty. Marcos thought of repudiating his barren wife. This solution came to nothing: he was bound by an absolute love to Erietta. Despite the strength of his feeling for her, he seduced ladies of Tabriz and lay with his serving women. He made none of them pregnant. In the end he was sickened by

those invariably flat stomachs. Then he searched his memory to identify his enemies. A dozen rubicund or pallid faces reminded him of the fools that he had ruthlessly swindled or the hard-pressed merchants whose panic he had exploited. It was likely that one of them was taking his revenge by resorting to the aid of a sorcerer. The evil spells had worked: Marcos Traboukis's seed was sterile. But the more he bowed to this explanation, the more he refused to accept the idea of having no heir. Attempts to break the spells failed. He finally decided in favour of a strategem that appalled Erietta. She begged him not to commit her to a stranger's embrace. He argued, she resisted his arguments. He flew into rages that did not shake her resolve. She yielded, however, when his verbal rants gave way to prostration. Pity and despair made her renege on a moral code to which she had adhered since childhood. She prepared herself to receive a transitory lover in the large marital chamber. Marcos Traboukis had a tall screen erected round the bed, with a low doorway in it. The space between the walls and the screen created a circular corridor. Marcos himself presented to Erietta a merchant crippled with debt who was passing through Tabriz. He made the introductions with a formality that brought a smile to the lips of the twenty-year-old youth, and a bitterness to his wife's. Only at that moment did Erietta detest her spouse. This husband who was forced to pander to his wife's infidelity heard whispers, moans and cries from the corridor. The young man left the room at dawn, handsomely paid as stipulated by a clause in the contract. Before the full light of day dispelled the last shadows of darkness the screen had been removed. But the months passed and Erietta's belly did not swell. Marcos wondered if his wife had not been affected by the curse as well. She disabused him of this idea by confessing that she had bribed the youth not to touch her. They had faked all the signs of shared pleasure. Her confession astounded Marcos, yet he did not reproach her for this ruse that condemned his name to oblivion, for he admired

the determination with which his wife opposed his own, and this made him love her all the more. Every night they coupled. But that moment of hatred that Erietta had experienced had taken root within her and now she unwillingly endured a passion of which she had tired of being the object. She had reached the stage of looking forward to meeting another man whom she would arm with a dagger.

Arnaud realized that Marcos's joviality marked only a pause between two bouts of deep sadness. The Greek hoped to derive a little comfort from his friend, but in this he was disappointed. Arnaud had changed. He was chary with any words of comfort and responded with silence to his friend's confidences. For no good reason he was loathe to relate his adventures, his successes and setbacks, what landscapes he had traversed, what people he had encountered. His fierce reserve destroyed their former closeness. Traboukis was hurt by such reticence, his explanation for which was the nefarious influence the regions of the north sometimes have on sensitive spirits. Living in those cold forests, wandering across infinite expanses of grassland eventually suppresses the inclination to share and the love of words. Arnaud did not dispute this. He offered the excuse that his vocabulary was so greatly impoverished that he felt ashamed to recount his travels. To dispel his former travelling companion's unfavourable impression of him, Arnaud described in halting phrases the house with the birds and, without identifying Hovsep, told of his crazy revenge, of the birds and the dark sky, and went straight on to talk in coarse language about the whore at Ercis and the unsatiated carnal desires that had been a matter of pride to him ever since. 'Well, then, avail yourself of my serving women!' said Marcos.

For a week Arnaud would ritually turn up at Traboukis's house in the early afternoon, with Hovsep always in tow.

Marcos chatted, preferably, about the military organization of Persia, about those Mongols who so readily cut off heads and were tolerant of all religions, and about the constant clashes between the Genoese and the Venetians. Erietta would make a brief appearance in the gardens to ensure that fruits, pastries and drinks were generously served, then she would slip away. Arnaud left these delicacies untouched, contenting himself with a carafe of spiced wine. Mildly drunk, he would then go and engage in the sensual pursuits that Marcos had generously encouraged. He entered his friend's house where, in some nook or other, a kitchen maid's naked body was always available to him.

Traboukis was then left on his own with Hovsep. The latter was bored by the Greek, who, lest too heavy a silence should develop between them, would launch into lengthy discourses, without feeling the least curiosity about him. One of these monologues dwelt on his desire to decorate the marital chamber with a fresco. Marcos was looking for an artist who could suggest various treatments of a theme he had settled on a long time ago. Hovsep told him about Vartan. Hethum's favourite illuminator, he assured him, would prove equally capable of painting wonderful fescoes. It would be easy to meet him. He offered to arrange it. Marcos agreed.

From the very beginning of his conversation with Traboukis, Vartan made no secret of his imminent departure from Tabriz. Therefore, he could only provide sketches. But Marcos told him that once he had started working on it, he might perhaps renounce this foolhardy journey. Capturing the purple tint of a pheasant's wing or with a single brushstroke introducing a dark glow into the folds of a cloak had weaned more than one man away from his dreams of terrestrial glory. Marcos then went on, without any sensationalism but also without reticence, to unburden himself on the subject of Erietta, avowing

his adoration and love. Speaking of these things, he was thrown into turmoil by using words that had not passed his lips for months. He was astonished to be confiding so freely in a stranger. Vartan leaned closer, the better to hear the confession being made. Marcos finally focused the ruthless spotlight of his confession on a deed of which he was ashamed. Soon there was nothing that Vartan did not know about that room where at her husband's behest Erietta had lain beside a venal young merchant. The Greek gave a long sigh, that of a man suddenly gauging the extent of the disaster he has brought about, and he pictured the woman he loved in the context of her daily life, when they were sweethearts. Abruptly he declared that the fresco was to depict three virgins with their arms entwined, representing the same woman at three stages of her life. They would symbolize innocence, love and death. He insisted that the face most marked by age should retain the traces of a past filled with affection and passion. And behind these three figures, looming over them, there was to be a cross with a dog crucified on it, for this was how he, Marcos Traboukis, wished to be portrayed, who by his madness had destroyed a couple's perfect harmony. Vartan promised to draw, and then paint three entwined women. In his mind, all three had Rhipsimé's features. Love would heighten with a pearly glow the smooth serenity of innocence, and death would hollow the cheeks that love had rounded. He gave no further thought to maps veined with rivers and shaded green with forests. Travelling would henceforth mean exploring the ineffable variations in the grain of the skin and in the joy filtered through heavy eyelids. And through his painting beauty would survive.

Vartan resorted to gestures he had only ever performed for a bishop or for his king: he kissed Marcos's hands and uttered words of filial tenderness. There had only been a chilly closeness between him and his father. But with this man he discovered the warmth that comes with lack of inhibition.

Marcos accepted Vartan's gratefulness. It did not surprise him or arouse his mistrust. This youth who had enchanted a court and a convent with his works had won him over as soon as he came into the garden. Not for months had he been shown such respect as today. So he stroked the head bowed before him. At that moment he felt that he was a lord, benefactor, friend.

The very next day, having visited the marital chamber, Vartan found himself in the small but airy room in which the careworn Greek made a pact with him unratified by any document. He applied himself to drawing on a light wooden board the outline of three figures leaning gently over a yet invisible spring.

At the time of day when fountain-stones paled, the blue of the sky deepened and the greenness of trees turned to amber, when churches, synagogues and mosques looked as though cast of the same bronze, Arnaud de Roanne would enter Marcos's house. He was about to make his way along a corridor for the seventh time when a woman appeared before him and took him by the hand. She did not smile, nor behave in any way provocatively. Erietta was true to herself. He considered freeing himself from the hand that held his, but he made not a single movement of his wrist. Erietta did not utter a word. As on the day when Marcos had introduced her to Arnaud, she confined herself to a nod of the head, a glance devoid of goodness and kindness. Without letting go of his hand, she turned away from him; she was his guide. There were internal courtyards and rooms crowded with lamps, cushions and chests. Arnaud forgot about Marcos. Neither shame nor desire disturbed his composure. He felt as though immersed in a dream, deaf to the distant murmur of the town where so many men from so many climes crossed paths, spied on each other, came face to face. Everything was extraneous to him, nothing impinged on him. But when she turned to him, he was impatient for the door to close behind them.

Erietta had brought him to the marital chamber. Beforehand, she had arranged for lattices to be set up around the bed, with flowing veils of blue-tinged drapes embroidered with chimerae, lions and silver roses. This screen of pale darkness constellated with monsters, wild animals and flowers would be taken down in the evening. So Marcos would know nothing of the delicate splendour with which his wife had surrounded herself for several hours. Arnaud and she passed through this silken rampart. Then cloistered within this chamber, Erietta Traboukis and Arnaud de Roanne made love.

Later on, after he had left her, Arnaud remembered the fluttering of the curtains and the shimmering loveliness of a body. That was all, and it was little enough, for the woman's face escaped his memory. And there was something baleful about this absence; it rendered insignificant the caressing beauty of the embroidered fabrics and of the skin's smoothness. He tried desperately to retrieve Erietta's features, but his memory obstinately denied them to him.

Three times Arnaud met with this woman and loved her. He formed no plan with her, the future was unimportant to him. And on every occasion, as soon as he went out into the streets after their lovemaking, Erietta's face became no more than an ashen oval, then an empty hollow, and finally a total darkness. Arnaud got used to this abyss, even though it made him suffer. But the fourth time he lay beside this body that he desired, he knew that her face would not vanish into the shadows any more. She had the self-abandon of a sleeping woman. He raised himself on his elbow and observed her. Every detail of the body offered to him was exposed like a landscape to the light, but an undecipherable landscape. Erietta was smiling. She raised her arm and her palm covered the roundedness and warmth of his shoulder. She sat up and her fingers moved towards the shoulderblade, traced the outline of a red mark on

his skin. During their first afternoon in the bedchamber, she had already noticed the disturbing blotch. Under the pressure of her fingers, the blotch turned the colour of wine. She pressed her fingernail on it, in the exact spot where the stiletto of the Bishop of Erzincan's emissary had so adroitly struck. Arnaud gave a brief low cry. Erietta made him lie on his stomach. She wrapped herself round him, her cheek against the nape of his neck, her hair spread over his back, and she kissed the bruised spot. When she loosened her embrace, it was to draw from beneath the bed a flask that she emptied on to his aching shoulder. The oily liquid smelt fragrant. 'This potion,' she assured him, 'relieves pain.'

She ordered now him to get dressed, gazing at him with extreme weariness. When he was dressed, she asked him to leave the room. He hesitated, but she kissed him on the lips, said goodbye, called a servant and turned away from him.

Arnaud walked through the garden, passed in front of Marcos and did not stop. Traboukis recognized the scent left in his wake as that of an unguent with which his wife some evenings oiled her neck, breast and stomach. He felt as though he had suddenly plunged into a pit.

That same evening Erietta ran away from the enormous house and Marcos hanged himself.

# XV

As soon as dawn broke, Montefoschi was scouring Tabriz in search of a map, for the one he had unrolled in the presence of Hethum had proved disappointing. He was especially concerned to find one that would reliably indicate a route that would make it possible to avoid the Pamirs. Spreading out a sandy-coloured map on his lap, he congratulated himself on at last having laid hands on what he had been hoping to find for days. On it were marked rivers and mountains identified by name. The man who sold it to him swore that it was the fruit of a Persian cartographer's long labour, and unparalleled in its accuracy. The Venetian placed three piles of tacolins on a small round table. The shopkeeper took two from each pile, felt the weight of them, made them clink and jingle in the hollow of his hand as if playing jacks, then he stacked them. 'It's a honest sum for such a marvel,' he said, 'and I think I'm going to let you have it for the price you're offering. But the most detailed of maps tell us nothing about certain regions. You may be the adventurer who will one day provide the actual location of a lake or oasis, an inland sea or a plain. Yet you cannot be unaware that the world is never stable. You're a child or a blind man if you say otherwise. Look closer and see this town marked with a cross: its position is exact. You'll stop there, make love to women, trade camlet cloth for ginger, unless the wind has gutted its ramparts and dispersed its stones, or an army has razed it to the ground, or raging waters have swallowed it up. Today you have before your eyes a city, and tomorrow it will be a crater or dunes. Maps guide us through a shifting universe. Accept this extraordinary truth from now on, and you'll be a real traveller.'

Montefoschi paid scarcely any attention to this lesson of wisdom. The unadventurous often bent his ear with such talk.

That evening he spent a long time studying the map. It gradually lost the precision that he had admired in the shop and soon was no more than an arbitrary tangle of lines, a chaos of rivers and forests, in fact a mist in which the continents lost all distinction. The parchment was inexorably absorbing any features and touches of green, red or blue. There were no winding courses or frontiers left, no towns or barren land, no countries or hypothetical islands, but instead a cracked and shrivelled animal skin. Until late in the night he swore as he used to when trading in the Crimea. The next day a child brought him a box containing the exact number of tacolins that he had paid the shopkeeper the day before. Hovsep was instructed to bring the shopkeeper to the caravanserai to discuss the matter. The returned heap of gold was no consolation at all to a vexed and disappointed Montefoschi.

The door was closed when Hovsep arrived at the shop. He hammered on it for a long time until the neighbours became annoyed by the disturbance.

'But why do you persist in knocking like that?' one of them asked. 'The owner of the shop left this morning for Baghdad.'

'Thank goodness,' another chipped in, 'for it's a bit worrying living so close to a man who practises magic.'

'The sorcerers of Tabriz are the most dangerous in the world,' added a third.

On the journey from Tabriz to the land of the Seres the greater peril came from the sands and winds than from the bands of brigands. Avalanches and rains often made the mountain paths impassable. It was essential to select reliable guides accustomed to difficult treks. As soon as he saw Kubilai's golden tablets, Sa'ad al-Daula, a Jewish doctor, procured two guides for Montefoschi. 'These are the most highly renowned guides in Persia,' he told him. 'If I had to go to China, they are the ones whose services I would engage.'

deceased. He chanted his love, despair and vengeance. Every one steered clear of him, leaving him on his own to sing his litany of grief and hatred. There was immense sorrow in his eyes, but also a terrifying violence that deterred even those most affected by the sight of this man.

He was reluctant to lay out his friend, for that would mean making the first gestures of farewell.

The sky was darkening to purple when Hovsep broke off his lament to sing another song, a melancholy one, dating back to ancient times, that he had learned in his childhood – a childhood of which this song was all that survived. Hovsep was like a shepherd intoning a psalm on the transience of terrestrial passions. His chant concluded on a high note.

The buzzing of an insect intermittently distracted Vartan from a torpid sadness. He also observed the dark velvet of the sky. He missed Marcos Traboukis. But understanding how one might be destroyed by an unbearable reality, he did not rebel against the choice Marcos had made to die. On the contrary, he prayed that it might be granted to him also to experience extreme emotions. His prayer was addressed to a nameless god who would judge neither carnal passion nor a woman's betrayal of her lover.

A pale golden line distinguished the horizon and in the courtyard of the caravanserai Hovsep's arms flailed the air. He reeled to left and right as if staggering under a burden, ranting to the four winds: Montefoschi's name punctuated his discourse. Hovsep was a spinning top, spiralling and whirling. Vartan locked his arms round him and whispered calming words in his ear. The man who behaved like one possessed gave way to a man who was crushed and broken.

Rummaging through Arnaud's haversack, Montefoschi found a sheet of rice paper on which was noted the composition of various potions. One was for convulsions, another

for hallucinations. Following the prescription, an apothecary in Tabriz managed to produce a syrup with narcotic properties. Montefoschi mixed it with the wine Hovsep was drinking. The effect was almost immediate: the man fell into a blissful coma and it was in this state that he was carried to a litter. Shortly before their departure from Tabriz, Arnaud de Roanne was buried in a little cemetery adjoining the church traditionally frequented by travellers on the way to China.

With the number of merchants reduced to less than half, the caravan was no longer the winding column of camels, mules and horsemen that had left Sis. Of the Armenian militia, a handful of soldiers still remained, while most of the troop were already on their way back to Lesser Armenia. This was what had been agreed between Hethum and Montefoschi. The king had assured the Venetian that beyond Tabriz ten strong lads, as well armed as those barbarians once at the gates of Rome, would suffice to guarantee the safety of his ambassador and artist. These stalwarts would be able to cut to pieces the worst of ruffians. Moreover, it would be bad policy to make an entrance that attracted too much attention in Peking. It was not fire and sword that Hethum was sending to Kubilai but the standard of faith.

The men panted beneath a molten sun. The litter lurched over a rocky path. Montefoschi was pleased to have overcome with medicine the rage of a one-time thief who had grown accustomed, very early in life, to biting the hand that fed him. At regular intervals he administered the narcotic to Hovsep, from whose lips foam trickled now and then. However, the sleeping man seemed calm. Vartan never intervened and let Montefoschi perform his ritual. 'Why hasten the return of visions and cries of vengeance?' he thought. And besides, he enjoyed the unbroken silence of the roads, which allowed him to think of Marcos, but also of the future.

Jeremy was just as Sa'ad al-Daula had portrayed him. He had the confidence of a prince guiding his people to more clement lands, without striving to interpret the flight of an eagle in an empty sky, or worrying about the drought that had dried

up several rivers, turning them into dust beds. Nothing seemed to affect his certitude of leading the caravan to its destination. He always rode beside Tremer. At every stopover they held long discussions by the fire. Montefoschi took exception to the affinity between them without daring to separate them, for to break up their close relationship would be to deprive the travellers of their knowledge of the routes, plains and deserts.

At night, in the communal room of the caravanserai, in the middle of open countryside, on the edge of a petrified forest, Jeremy became a storyteller. Among the ruins of Saveh, he would conjure up the presence of wolves in describing a world where winter was the only season. Sand would trickle through his fingers, and to the Franks it looked like a sprinkling of forgotten snow.

During the day he was their stern guide and the falcon that sees the twig even at the bottom of the precipice. He warned of ravines and just by tipping back his head and observing the summit or the slope of a steep hill anticipated an imminent rock-fall. He noticed everything, the tracks of the wild ass or gazelle, a fox's lair or the traces of an ancient battle. He would name the towns out loud: this is Aveh, or this is Kashan. He read history in the ruins, or in the sand. Listening to him, Vartan remembered his father, for whom a field was never a mere expanse of grass on which animals pastured. 'Remember,' he would say to his son, 'that long ago this field was chosen as the place where a victory would be won.'

For seven days the caravan progressed through a landscape of rust-coloured scrub. Where the men and their animals passed by, tufts of horsehair and scraps of material were left hanging from the thorn-bushes. There was wild game in abundance. Pheasants would fly up from the ground cover. The soldiers,

some of the merchants and Montefoschi would shoot them with their bows and arrows. They roasted the birds against a backdrop of stunted trees. Chewing the smoky flesh, Jeremy detected deep inside himself the echoes of a hunt in which the deer is streaming gold and the huntsman a devil. At dawn, an ocean-green suffused the East. There were pink glimmerings and the darkness was finally overcome.

A broad grey plain led to the kingdom of Kerman. Whirling tornadoes of Mongol horses had shaken this ground. The memory of a sky darkened by a hail of arrows still haunted the inhabitants of this land, from which turquoise was extracted. Jeremy picked up a few bones on the outskirts of a village. A child had died here. He came under suspicion of wanting to reduce to dust the last vestiges of a crime or of a body that had succumbed to lack of water. He explained that a lengthy alchemy might perhaps convert these bones into turquoise. His explanation was greeted with laughter. But from the very next day there were many who secretly filled their bags with the smallest fragment of these skeletons of man or beast strewn along the roads.

The whole kingdom of Kerman resounded with the hammering of steel, and reeked of leather tanning. In one small town Montefoschi equipped himself with harness, saddles and bridles. In every town Montefoshi had the camels loaded with provisions of flour, strips of candied melon, and dried meat. He fed the merchants at his own expense, for he wanted to display lavish generosity, like a king. In order to do so, he drew on his personal funds. In Tabriz he had made Vartan responsible for keeping the accounts, and the monk was beginning to grow alarmed at the constantly increasing expenditure. It was wilful caprice to offer free hospitality to people who all had money of their own. Sharing his supplies, spending hours choosing food from one stall rather than another was also a

way for Montefoschi to suppress the memory of Hovsep's love and betrayal.

Jeremy and Tremer distributed the wine and meat. And the Venetian observed the scene from a distance. The more he divested himself of his money, the more he spared himself any dealings with the travelling merchants and soldiers. He was indeed a generous king, but a king who did not mix with the common people.

While extending Hovsep's slumbers for days on end, Montefoschi retained the hope of resuming his former relationship with his travelling companion. So he reduced the doses of the narcotic and began to watch the sleeper's face for the slightest quiver that would alert him to his awakening. In fact he looked forward to seeing the thief of Ayas's figure standing in the doorway of his bedroom. That is why he now left his door ajar in the caravanserai.

# XVIII

The caravan stopped for three days at Kuhbonan, where Montefoschi learned that halfway between this city and Sheberghan a band of brigands was robbing travellers. Once they had stolen their gold and pillaged their goods, they unsheathed their daggers. The human corpses added their stench to that of the animal carcasses. The area in which these marauders operated was recognizable by the foulness of the air. Instead of scaring him off, this danger spurred the Venetian on, for he would at last have the chance to display his invincibility and cunning. So he bought yards and yards of dark heavy cloth, piled firebrands of resin in the litter, and had a wagon loaded with stakes, spears and caged poultry.

The land stretching from the gates of the town was barren. In the middle of the day he called a halt in this ochre wasteland. He said to himself, 'God favours mirages on this desert soil, so as to lead the traveller astray and thereby punish him for his unbridled desire for adventure and riches. Well, beneath this burning sun, I shall be the god who tranforms an ordinary caravan into a vision that sows panic among the bandits. I shall be the god who refuses to lose in the sands men glutted with ambition and is able to avert disaster and ruin. I shall in the end be the one who leads them to the East.'

He addressed the men, told them the reasons for this halt and issued orders with such authority that these were carried out without too much protest. From now on, the daytime was for resting and the night would be spent travelling, he declared. It was agreed that at every bivouac, they would build big fires to form a complete circle containing the animals, valuables, and men. Between the fires, spears and stakes would be driven into the sand on which chickens would be impaled. The unbearable summer heat would make them rot faster.

Finally, traders and soldiers, guides and interpreters were to wrap themselves in wide strips of black cloth. The horses, camels and mules would be caparisoned in the same fabric. And so too would the wagon and litter be covered with black cloth. This strategem, Montefoschi concluded, was the only one that might create an impression and therefore keep away the robbers and cut-throats that were rife in this region.

As he predicted, the stench and the fires marked a boundary that the robbers never dared to cross. Sometimes they heard the sound of a cavalcade in the distance and sometimes motionless presences in a sand dune spied on this gathering of spectral creatures. At sunset the caravan would set off, silently, leaving the gutted birds to vermin and to darkness.

Each person held aloft a lighted torch. A single blaze then appeared to undulate above a long soot-black serpent. Anyone who saw it moving along at the dead of night would imagine he was watching the creeping progress of some supernatural creature emerged from Hell, making its way towards the towns to install a reign of fear there.

At last they were nearing Sheberghan. During the tenth and final stopover, the men noticed some change beyond the fires. They listened to the sheer silence of the desert: no sound of hoofs, no dark figure on the ridge of the dunes. The brigands had surely gone for good, abandoning the strange procession for fear perhaps of spending too long in close proximity to these sorcerers who worshipped fire and carcasses.

The merchants, whether they were Armenians, Persians or Franks, would always remember this journey. The first time they rode their horses dressed in black, they were taken with the idea of resembling bats. Then they forgot that similarity, for it began to astonish them that with just a torch and some impaled chickens they were able to defer and even prevent an attack by brigands. No, that was not sufficient to repel the

danger. So, they began to entertain the idea of their meta-morphosis into untouchable creatures, into princes of divine ancestry. Besides, as was said of God, they felt neither hunger nor thirst. But this feeling of theirs was shortlived, for near Sheberghan they put the last of the poulty on the spit and roasted it, and with their mouths and fingers smeared with grease, without realizing it, they reverted to being like any other travellers, that is to say, insignificant little people, and given the opportunity cruel and cunning. Their thoughts turned, as they often did, to gold and silver mines, to the most important trading centres of Bactria. But in getting used to being themselves again, they suddenly appreciated how different they were from Montefoschi. It was undeniable fact: the Venetian, Vartan, Jeremy and Tremer, who were eating a few paces away from them, and had removed their black attire, radiated a certain grandeur.

In the morning Montefoschi asked all his companions to say nothing about their artifice, for there are regions, he warned them, where the story of what had happened might be inter-preted as a sign of sorcery and then there would be a great danger of ending up burned at the stake or being stoned.

Hovsep opened his eyes. He felt that he had regained strength. He could now cross and uncross his arms, bend his legs, lie on his side or his stomach. He no longer sank into bottomless dreams. Today his captor had fed him a bowl of broth and scraps of meat chewed beforehand to make them easier to digest. But Hovsep had not revealed to him either the nearly recovered suppleness of his limbs or the fact that the mists were clearing from his mind.

# XIX

Some monks on a pilgrimage had seen the undulating fire in the desert night. Already by the time the caravan arrived, the tale was spreading through the streets of Sheberghan of a flame-crested dragon and of an encampment that had appeared from the earth's entrails. Montefoschi wanted to cut short his stay, but the merchants firmly opposed this, on the grounds of their tiredness and of business interests that detained them in the town. The Venetian gave way to their arguments. Unlike Hovsep, he was unable to invent stories to make them leave immediately.

In this town Vartan was present at endless discussions among Nestorians and consorted with Mazdeans. But he was more responsive to a laugh, the sound of a voice, the sight of a bared shoulder, of a sleeper nestled in the shadow of a wall, than to any verbal jousting. In reaction to the austerity of the landscapes he had just traversed and to the silence imposed by Montefoschi, he sated himself with the diversity of men, customs and beliefs. He wandered about the markets, without ever tiring of the fragrances in which he steeped himself. He went to the baths and remained there for hours, observing the bodies passing before him. When a youth eventually invited him to retire to somewhere private, he left the place. But back at the caravanserai he regretted having refused the invitation, because he had felt desire for that young man. However, he did not return to the baths, not yet daring to experience what Montefoschi and many others were doing.

# XX

An inscription on the pediment of one of the gates of Balkh stated that the town had been built to the greater glory of God and by the will of the sultan had been turned into paradise. But for decades now, all that was left to see of Balkh was a vast expanse of ruins, for the Mongol army had laid it to waste. The conquerors had assembled a haggard population beneath its walls. Soon the only sound to be heard was that of sabres falling on necks and horses stamping. The survivors of the massacre swelled the long column of slaves. A fire brought to an end the prosperity of both a city and a region. Like some gigantic tubular stone, the gate of Balkh, alone, was still standing.

Trees poke through a heap of rubble. Here and there clumps of vegetation dot a disaster-stricken landscape. Shepherds and their goats seek out what little shade is left since that day, already long ago, when Genghis Kahn's soldiery set gardens and orchards ablaze.

The caravan stopped close to some crumbling fortifications. The eye immediately took in a chaotic disorder of stones occasionally resounding with the fall of a pebble. Few travellers were bold enough to take a stroll through this labyrinth of demolished architecture, this silence of devastation, this destroyed world. Time was at work, erasing a place that was like a nightmare, still boasting a few last vestiges of dazzling splendour.

Vartan was appalled by this motionless upheaval of mineral festooned with huge plants and abandoned to birds, reptiles and insects. A city reduced for ever, there was nothing left of Balkh that invited libations or promised repose. With a dry

throat and sticky hands, Vartan wrapped himself in his cloak, wanting to deny reality, wars and invasions, torture and beheadings. He also wanted to forget the furnace-like heat of the day and the cold night that was to come, and remember only the baths of Sheberghan. Then he fell asleep, rejoining in his dreams that youth who had promised him pleasure.

Meanwhile, Tremer and Jeremy scrambled up pyramids of gravel and danced on the edge of a well choked with beams. They goaded each other amicably, and tussled without ill will. An almost unseemly presence in this grim post-cataclysmic setting, these shockingly cheerful rascals took over the place. An identical smile remained perpetually on their lips, and an identical expression lingered in their eyes. Some obscure kindred spirit united them. They seemed to reflect each other.

Montefoschi watched them running about, their paths interweaving. He was bemused by the two lads' energy. As predators with their prey, they wearied him with their constant darting to and fro. He showed quite unaccustomed indulgence towards them, without voicing a word of reprimand or making any move to stop their games. All at once he grabbed them by the sleeve, chided them like cheeky schoolboys, and suddenly fascinated by their mirrored gestures, exclaimed: 'Calm down, twins!'

'Twins?' Tremer said derisively. 'No, friends, rather, united by our hatred of the most powerful man in Tabriz, Sa'ad al-Daula. Now, you, a man whose greatest weakness is probably your credulity, let go of us.'

That they should have accused him of credulousness at first infuriated the Venetian, then he said to himself that sooner or later he would make them pay for their insolence, and if not today then tomorrow he would force them to confess the reason for their hostility towards the famous Sa'ad al-Daula.

\*

On the tiles of what had once been baths, branches and trails of ash formed a strange pattern. Montefoschi attributed a meaning to them, and interpreted them as soothsayers interpret a bull's entrails. From a jumble of lines he picked out his future, in which he saw a star that by abruptly veering from its orbit would cause disaster. In Venice, he had once spotted a comet in the sky, crashing into invisible objects. It suddenly broke loose from the celestial vault and ended up plunging into the sea. It was at exactly the same time that the Genoese sank several of the Republic's ships. Their victory presaged the Serenissima's decline, as surely as the fall of a star had done so. What had happened to Venice was what lay in store for him. Everything gave him reason to believe so: the leafy contours on this filthy floor, as well as the ruins surrounding him. Balkh was the mirror of his demise.

The litter had been placed at a distance from the encampment. This was decided by the Venetian, for he was fed up with sleeping alone and planned to join Hovsep – but to do so unobserved – during this first night at Balkh. Darkness had fallen when Montefoschi lifted the curtain: the litter was empty. All that remained of Hovsep was a smell of rancid wax and urine, which Montefoschi liked because it reminded him of someone who was entirely in his power, even if it now indicated his absence – but this he was unwilling to admit. So, he climbed into the litter, fell back among the cushions, and felt as if he was foundering and at the same time embracing the memory of a body. Although his hands were able to stroke the woollen overcoat with which he covered Hovsep every evening, the illusion did not last. He experienced the pain caused by a desertion that he nonetheless refused to believe was final. He wrested himself from this sump in which Hovsep had wallowed and jumped down to go in search of the man for whom he still nurtured a passion.

★

The merchants were sleeping. Montefoschi, who once had no hesitation in interrupting his companions' sleep on the slightest pretext, was reluctant to wake them. Vartan was still wrapped in his coat, immersed in his dreams, indifferent to the darkness of a dead town. So he left the young man alone, unbothered for a few hours more by the irrational behaviour of human beings. Yet he did ask the Armenian if he was cold, and was happy just to hear the sound of his own voice. All of a sudden he felt certain that Hovsep had not left Balkh. The litter steeped in deep blue drew him like a magnet. He went back to it. This was where he must wait.

But losing patience, Montefoschi slashed the cushions. He then gave way to the unrestrained hilarity of revellers, and afterwards buried himself among the feathers. With his hands crossed on his chest, his eyes closed, his breathing regular, he looked like Hovsep, lying still and unconscious, deaf to the murmurings of the desert, blind to the crest of flames borne by men on the move. Now like the Armenian, he was the bear hibernating in the depths of his cave.

Balkh was rife with scorpions and beetles, rats, rabbits, vipers and beasts of prey. On its pavements, at the foot of broken columns, in every convolution of stone, from the moment the sun went down, all kinds of animal species were out on the prowl, watching each other, at each other's throats, squealing, growling, mating. Miniature warriors harried the dying rodent. Cries resounded from the four corners of the town; cries of panic or rallying cries, cries of satisfaction and rage. Hovsep wandered aimlessly through the silence heightened by these cries. He often stumbled, his knees and palms bled, as he scrambled over a chaos of ruins.

He felt the desire to kill, but his hands were not those of a strangler any more, and his thigh muscles had been debilitated by his prolonged immobility. Soon, he hoped, he would have

regained his strength. Then he would deal with Montefoschi once and for all.

The darkness going to his head, he barked insults at the moon and stars. Their predictable nightly appearance reminded him of a life brought too soon to a close. He renamed the Great Bear, calling it Arnaud de Roanne, for in the arrangement of the stars he saw the outline of a body. He lay on the ground and stared at the twinkling sky.

At dawn Tremer heard a strange stamping. Thinking robbers were upon them, he raised the alarm when he saw a man untying bales. It was then that he recognized Hovsep. All around him, wine was flowing from upended wineskins, dried meat and fruit were scattered over the sand. A piece of silk had been soiled with excrement, and cotton fabrics had been torn.

On Tremer's orders, the soldiers seized Hovsep, tied him to a stake and began beating him. The merchants joined in. Their shouts of anger woke Montefoschi. The face that greeted him was a bruised one. The men calmed down at the sight of the Venetian, consigning Hovsep to his jurisdiction. Yet one Armenian dared to suggest that this maniac's hands should be cut off. Montefoschi was divided between his joy at finding the runaway, and his duty to punish this lunatic whose vandalism had seriously reduced the caravan's provisions. However, he made some unfortunate comments, playing down the loss of fabrics, and the money he offered as compensation did little to pacify the victims of the damage. Discontent redoubled. Montefoschi could not avoid passing sentence. But before condemning him to some kind of punishment, he told them of Hovsep's past. Ballads of the following century would relate the story. The Thief's Song and Barebone's Lament would be sung by landed folk as well as peasants and vagabonds. While recounting the elements of Hovsep's life, Montefoschi tore off the man's clothes. He came to the penalty that had been inflicted in Ayas just as he

finished stripping him. Hovsep's mutilation was now visible
to all. The merchants' anger suddenly subsided and there was
a general sense of embarrassment. They dispersed without a
word, but resolved to slit Hovsep's throat if by any chance he
were to repeat his antics.

Vartan cut the rope lacerating the culprit's arms, and Monte-
foschi clothed the nakedness of the man he had humiliated.
Hovsep was then seated on an ass and Montefoschi whipped
the animal's rump. The rider and his mount were soon no
more than a small cloud of dust on the horizon.

# XXI

The caravan headed north-east.

The travellers were relieved not to be spending any longer than three days encamped at the gates of Balkh. The fire-blackened town was like a ghost that exercised a gloomy influence over their thoughts. They were impatient to leave a place where Montefoschi's compelling gestures and fiery words had mortified a man by revealing his secret. They expected the Venetian sooner or later to divulge some of their own misdeeds, for they had stabbed a witness to their shady transactions, slandered a relative to ruin his reputation and procure his clients, pierced a youth's intestine by shoving the handle of a hoe up his arse. There were those among them who abominated heaven and the angels. They were all afraid that Montefoschi knew their most condemnable offences. Some intuition curbed any desire they might have had to anticipate his revelations by venturing to accuse him of sodomy, murder, and blasphemy: they suspected the man of having dealings with evil spirits against whose power they were helpless.

Shortly after the city of Khanabad, the caravan passed some turbaned warriors, then some huntsmen whose mastiffs were worrying a porcupine, against a backdrop of salt mountains that looked grey, as if perpetually shrouded in a wan light. But these encounters and this monotonous landscape were forgotten when a wild horse mounted by Hovsep appeared at the end of a pass. The rider galloped along some distance away in parallel with the caravan, and not once did he attempt to draw any closer. But at night his horse could be heard stamping and moving about incessantly.

\*

From the moment Hovsep appeared, Montefoschi shrank in his saddle and began moaning. Like the Armenian at Arnaud de Roanne's bedside, he intoned a doleful plaint that was both invitation and entreaty. He invited on himself death by the sword, and entreated the outcast and the spirits of the plains and plateaux to call a halt to a trek grown absurd since the betrayal of his love. And was not it the worst of crimes, he thought, to try to humiliate the one you loved and to succeed in doing so? Was it not, then, just that the hand of the humiliated should deal the fatal blow?

On one of the last evenings of October the earth seemed to tremble beneath the hoofs of a herd of one thousand animals. Hovsep's horse whinnied in the distance and Hovsep uttered the scream of charging Mongols. Suddenly the plain resounded with an interminable harsh bleating. Big white rams with twisted horns swept over the tall-grassed plain. They formed a broad frieze that broke through the night mists. Their breasts and flanks were stained with the mud and pounded grass raised in their rampage. Hovsep was every-where at once. He drove them towards the camp the way beaters drive a bevy of deer. In their diabolical onslaught these wild sheep overturned tents and caught men and pack animals in an inescapable vice. Horns dug into the stomachs of camels. The men flailed their arms, trying to protect themselves by running to take refuge from the deadly assault behind some rocks. At that moment every one of them wished he was made of stone. The fires were trampled under the weight of a bellowing war machine. Embers were scattered. The air smelt of singed fleece and horn. Then the mass of sheep wheeled round dramatically. This change of direction left not a single tent pole standing. The ground turned into a filthy mire. And suddenly the crazed herd abandoned the encampment and went charging on into the darkness.

When dawn broke, a state of shock prevailed among the

travellers whose eyes still were filled with terror. Eight of them had been disembowelled. They were buried in churned-up ground. It was Vartan who celebrated the funeral rites. Rediscovering the words he used to recite at Sguevra, he chanted some verses. His voice was that of a shepherd surrounded by wolves, imploring the help of his god. In the morning they went in search of the horses and camels that had broken loose and fled across the plain.

The thundering horde of wild sheep wrested Montefoschi from his moaning. He struck several of these furies with his sword and his howls of rage were heard by his travelling companions despite the tumult. But once the beasts had disappeared into the night, his hands immediately dropped the weapon and his eyes scoured the absolute darkness: Hovsep was invisible. After that, Montefoschi remained indifferent to the cries of the wounded, the croaking of dying animals and the braying of those that had escaped the hooves and horns.

The merchants were angrier than ever: the damage to their property was considerable. They blamed Montefoschi for being the author of their misfortunes. Their despair was such that they now did not care about offending a man with a cohort of devils at his service. Despite Vartan's intervention, they lay hold of him, whipped him, and threatened him with the punishment inflicted on Hovsep in Lesser Armenia. They vowed to organize a man-hunt, to bring back alive the befriender of rams and force the Venetian to cut his throat. But three eagles wheeled in the sky, three eagles that slowly descended towards the clamorous group of travellers, and dispersed them with their wings. The birds of prey came to rest beside Montefoschi. They showed no aggression; they calmly searched themselves for lice. Then they settled on top of their protégé, assuming the stillness of dead birds. The silence of the stones, the sound of the wind blowing, and the men's taciturnity answered each other. Suddenly the eagles shook

themselves, rose and lifting with one accord took flight. Beneath the palpitating mantle of feathers Montefoschi felt his body regain strength and his heart beat to same rhythm as that of the birds'. He picked himself up and when he was back on his feet he had no recollection of the merchants' fury or of the winged triad. He was merely amazed by the marks the whip had left on his skin and by the reverence or dread to be seen in men's eyes.

The twins of Tabriz solemnly distributed among the merchants dirhams and tacolins drawn from Montefoschi's coffer. The man was no longer the sorcerer who, they believed, coupled with incubi, but on the contrary he had become almost a saint. A miracle had conferred on him an aura of prodigy. His generosity, which he had already demonstrated, finally overwhelmed them. They offered their thanks, paid him reverence, prostrated themselves before him. But the Venetian did not bestow his blessing on them, treating them bizarrely with a kind of haughty indifference, apparently concerned only with his wounds, which he asked Vartan to treat. The latter took advantage of the opportunity to warn him that the coffer was almost empty, destitution was imminent, and their joint resources would not suffice to meet the expenses of a long journey. This absurd improvidence was becoming cause for alarm. But Montefoschi seemed to take no notice of these warnings and pleas from Vartan – who, it is true, was touched at heart by the recklessness of this man who thereby distinguished himself from his fellows and displayed a freedom of existence worthy of considerable respect. So, pondering further on the extraordinary episode of the eagles, the monk, having raised the alarm, decided to set his mind at rest, assuring him in a burst of affection that poverty would never frighten him: better still, he would even take to begging.

But Montefoschi's mind was elsewhere, and he was listening out for other dangers. Hovsep was approaching. And

indeed, Hovsep was there, on his horse, close by, on the plain, some one hundred metres from the devastated camp. Alerted to this, the merchants then made a dash for their stallions and mounted them. 'Look at him, defying us!' cried one of them. 'He shan't escape us, this bewitcher of rams who seeks our death!' Hovsep immediately dug his heels into his horse and led his pursuers towards a thickly shrouded horizon. And the merchants were not the dispensers of justice they had hoped to be. They lost their way in the fog and floundered in marshland. One of them became mired in it. In this murkiness what chance was there of finding him? He called for help, then eventually fell silent. At last the sun broke through, shining on ground from which thick mists were retreating. To avoid the same death that had befallen their companion, the horsemen decided not to go any further across that expanse of quagmire. Confounded and chilled to the marrow, they returned to the camp, then set off once more on the road leading to Talogan.

# XXII

At Talogan every last piece of fabric that had been saved from the frenzied trampling of the rams was sold. The money was used to buy rubies. And then they would have left, but Montefoschi delayed their departure for three months.

The Venetian was oblivious of the town. Prostrated for hours on end, he could then give way to fits of rage. Yet sometimes, it seemed, he meant to return to less extreme states of mind, but it was only an illusion. All of a sudden he would start persecuting Vartan and the twins with his demands, and abuse their loyalty, obedience and concern for him by forcing them, without respite, to go roving the streets of a town that sooner or later, he was sure of it, would yield up Hovsep. His uncontrollable impatience did not deceive him: the man was surely lurking among the passers-by. Vartan and the twins thought they caught sight of him on a square, in the middle of a courtyard, at the window of a house. They were constantly detecting him in their path, but as soon as they thought they had the better of him, he would slip away. Sometimes he wore a kind of turban, sometimes a conical felt hat, sometimes he went bare-headed. One day he seemed to have gained weight, the next his features looked particularly wasted. Vartan, like the twins, came to doubt having recognized him. When they identified him at a casement window, they forced the door of a dwelling only to find themselves in an empty room.

One evening Montefoschi was visited by a shadow. It striped him naked. He did not resist its caresses. The shadow roamed tirelessly over his abdomen and between his thighs. It licked his neck and torso, kissed his lips, cooed, laid him out in a cross shape, rubbed against his side and resumed its sensual

exploration. It suddenly broke off its snugglings and embraces, slipped out of bed, and with sneering laughter swiftly left him on his own. The next morning the shadow sent a child as a messenger, who recited his communication to Montefoschi: it was an arrangement to meet him in one month, to the day, outside Talogan on the road to Ishkashim, the last staging post before the Pamirs. That morning Montefoschi was like the Venetian of old, curt, ambiguous and merciless, playing on his ambassadorial charm – an ambassador whose projects had been smiled on by a king – and this charm persuaded Tremer and Jeremy that they would not come to grief if they crossed the Pamirs in February. With Vartan, who was again worrying about the depletion of their finances, he put on a knowing air, while patting his belt and eyeing his breeches meaningfully: they contained the gold that would keep them from bankruptcy for a long while yet. Finally, he opened his coat: Kubilai's tablets glinted on his chest like a breast-plate.

The caravan comprised only sixteen men now. For many had proved resistent to Montefoschi's charm. Moreover, as they expected nothing good of the snows of the Pamirs, wisdom advised them to postpone a crossing that could not but be dangerous at this time of year. Having bowed to the Venetian's will, Tremer began to doubt the success of the enterprise. But although he disapproved of it, he did not oppose it. Strangely, he foresaw the worst and found himself calmly imagining the end he would meet.

Hovsep kept his appointment. A fine teeming rain fell from a lowering sky. As soon as Montefoschi saw him, he opened his fur-lined coat to show him the breast-plate and invite him to renew their ambitions and dreams. The other kept his usual distance from the caravan. Since he looked as if he was not going to react to this silent invitation, Montefoschi squeezed his mount's flanks with the intention of joining him. He had

not reckoned on Vartan and Jeremy, who instinctively barred his way. He tried to force them aside with his riding crop. Then there was a scuffle. When he dropped his riding-crop, he used his fists. He did not so much land any punches as gesticulate. Vartan and Jeremy countered with oaths. Jeremy gave a cry when Montefoschi unsheathed a dagger. He briskly urged his horse close to Vartan's to let the Venetian pass. But Montefoschi did not have time to ride up the gentle slope that would have taken him to Hovsep, for a fourth rider burst onto the scene. Tremer hung from the side of his horse, clinging to the pommel of his saddle with one hand. With his free hand he managed to slip Montefoschi's foot out of the stirrup, then lift his unanchored leg and thereby unseat him.

Now the Venetian was lying in the mud, but this time there was no eagle wheeling in the sky. Voices around him called for the culprit to be killed. He thought that he was to be the victim. It was then that he heard Hovsep scream with pain. A soldier had shot him in the shoulder with an arrow. A few seconds later a second arrow hit him in the side. A Persian prevented anyone from going after him. It would be a long drawn-out agony. What more did they want?

Hovsep survived his injuries for two days. He continued to accompany the caravan but the distance between them increased. The horse hobbled, as though under the weight of too heavy a burden. As if to encourage the animal, from time to time the wounded man would lean forward and wrap his arms round its neck, hugging it. His clothes were soaked in a single stain of blood, and the rump, chest, mane, and withers of a fine steed were dyed crimson. At every moment man and beast were in danger of stumbling and falling to the ground through weakness. The horse sometimes refused to go further. Then the horseman goaded it with the arrow pulled out of the rounded flesh of his shoulder. And he and his mount were as one.

On a night with the bitter savour of eternity Hovsep

applied a paste of crushed grasses to his wounds. The blood clotted under this daub. Eventually the latent gangrene became evident. While he was preparing his medicinal treatment, the revenge that had been his obsession since Tabriz was forgotten. He remembered Arnaud, that was all.

And then it was dawn. The horse stumbled over some dead wood, refused to continue its slow progress, went down on its knees, then rolled on to its side. It shuddered and stiffened. Circling falcons appeared in the sky. Hovsep remembered an aviary, a frenzy of birds, a fountain, Arnaud's unexpectedly friendly glance, the birth of a friendship in a town where men were dying. Then he fell asleep, staring at the timidly rising sun suddenly masked by a myriad of dark wings. Life drained out of him, and took with it the presence of love. Claws fastened on to his remains and beaks tore at what had been face, body, and suffering.

# VARTAN'S STORY

# XXIII

From then on Montefoschi revealed plainly, through his behaviour, the two sides of his personality: on the one hand, the clever talker, of thoroughly obliging wiliness, pleasant towards his travelling companions, affectionate with the twins, putting to good effect his remarkable ability to handle people, supervising preparations for the crossing over the Pamirs; and on the other, the private man, the lovesick chagrined loner, haunted by the image of Hovsep's blood-red body, shunning caravan and travelling companions to retreat into isolation, on which only Vartan seemed to entitled to intrude.

At Ishkashim he drew up a will in favour of his protégé. One clause made provision for some personal trifles to go to members of his family, whom he vaguely remembered because they had been friendly towards him during his adolescence. Assuring Vartan that he regarded him as a son, Montefoschi gave him the parchment, in which the monk took little interest: he was young, free of any desire for possession, except that of capturing the colours of the world. The Venetian's gesture seemed melodramatic to him, the act of a weak and troubled soul. But out of respect for the man, he accepted the role that had been assigned to him.

Montefoschi now wanted him at his side at every hour of the day, and Vartan yielded to this. The Venetian embraced him warmly and kissed his forehead on parting for the night. He was ridiculous, foolish and sentimental. Vartan was left in no doubt that this unsolicited affection was superficial; nevertheless, it might yet flourish for many a long year. But the man's presence was no burden to him: all his thoughts were set on the Pamirs, a universe of ice and wind. He wanted to be ready to overcome the hostility of a wilderness of snow, convinced that a strong spirit must confront what it most

fears. And what he feared was the thought of the numbness that the cold, the mineral desolation must create in man. He wanted to learn how to overcome the deadening of the senses, to sharpen his sensitivity to the chilling purety of the barren waste. After his departure Ishkashim was left with the memory of a cheerful and lively youth, consumed with impatience.

Yaks had joined the column of robust stocky horses and woolly-coated camels. The travellers were obliged to wrap themselves up in fur-lined coats and wear wolf-skin boots on their feet. Their movements hampered by so many layers of clothing, they had difficulty in hoisting themselves on to their mounts. Their departure from Ishkashim took place in total silence, for the men knew this was the beginning of an ordeal. And yet they hoped that Montefoschi would prove capable of guiding them to Peking, to that imperial court said to be without comparison, and that he would also show the cunning and intelligence which he had put to good effect to ward off those bandits. With his determination to succeed, had he not helped them to overcome thirst and hunger? They placed great trust in him, although agreeing among themselves that Hovsep's death had been a crushing blow to him. They sometimes caught a distraught look in his eyes.

The peaks were crowned with a white forbidding spume: clouds and snow became one. A lunar landscape beneath a smoke-coloured sky. When they reached the first pass the birds disappeared. They gradually grew accustomed to the scree and the snow.

The third day was distinguished by a very intense cold. There was bleeding from the beasts' muzzles and the blood immediately froze. The men too suffered nose bleeds which they tried to staunch by holding a cloth to their face. And when they

looked at their companions, they scarcely recognized one another.

Little brownish sores appeared on the camels' bodies. Tremer developed identical ones on his neck, face and hands. When he warmed his hands over the fire in the evening, fluid could be seen seeping out of them. No one suffered from the cold as much as he. Winter embedded itself within him and his body seemed to fossilize. With fingernails that had grown inordinately long, he frantically scratched his sores. This activity would allay for a while his sense of being frozen. But all this ice inside him suddenly oppressed him and death seemed close. Fortunately, Jeremy was never far away.

The caravan crossed two broad rivers that looked like ice banks. Tremer declared that the ice would hold. He was not mistaken: they could vaguely see the turbulent flow of water beneath that green and very thick opaque expanse. Since being penetrated by the cold, Tremer rarely spoke to his brother. No more of those conspiratorial whisperings, murmurings, subdued laughter that had so exasperated Montefoschi. Moreover, the Venetian noticed that, deprived of these private conclaves, Jeremy did not inspire confidence in his capacity as guide. Was this even the same person, he wondered, whose expert talents Sa'ad al-Daula had extolled. But then who was he? Touched by the boy's devoted care for Tremer, Montefoschi did not even seek a reply.

Jeremy yapped out contradictory orders. These were greeted at first with astonishment, then wariness, finally there was alarm at their incoherence. Montefoschi restored calm among the men by advising them to keep heading East, for it was in that direction that China lay, and sooner or later the Pamirs would come to an end.

The travellers braced themselves to fight against the elements.

Snow had been falling continuously for three days and three nights. In his tent at night an abstractedly maniacal Montefoschi would clean his dagger unnecessarily: this region had the reputation of being spared of robber bands. Besides, they never passed a living soul on their way. Vartan entertained him by relating episodes from the life of Alexander the Great. Then Montefoschi would look up and ask Vartan if, like that emperor, they would ever arrive safe and sound in more clement lands.

'Why on earth did I ever persuade you and the others to follow me in winter, on a journey that pilgrims and soldiers have always regarded as madness?'

Vartan would reassure him. 'Today, the snow is endless,' he said, 'but tomorrow it may give way to grassland. And even if it doesn't, I know that you and I will be stronger than the winds and the cold, stronger than this snow that at this very moment threatens to bury us. I swear to you, we shall be what we are meant to be: two men who will reach Peking, unbroken. What are the Pamirs? A very long distressing dream, nothing more.'

A pale light slowly spread across the sky. It was early. As he was sometimes in the habit of doing, Montefoschi wandered among the fettered beasts and sleeping men. He liked to take advantage of daybreak to calmly take stock of provisions and check that no illness had broken out among the animals during the night. That morning he found two horses dead. These first victims of exhaustion and the cold were to be followed by many more. He knew this. But as he went up to them, he noticed blood on the neck and rump of one of them. Then he saw the footprints of a wolf in the snow. So, from now on, as well as the cold and exhaustion they would also have this to contend with. And although Vartan had inspired him with hope the previous day, Montefoschi was entirely pessimistic about the future. When he informed the others, the most

cowardly among them began truly to doubt that they would ever come through the Pamirs alive.

The caravan entered such narrow passes that it became necessary to unload the yaks and camels. Then it was the men who carried the packs on their backs. Dazed with fatigue and despondency, they felt empty-headed, devoid of the slightest memory – an arduous childhood, a lover, an advantageous business deal, a garden with its fountains, revelries or rivalries among the guilds. Each one was a desert.

The sky darkened and the snow grew deeper. An interpreter and a soldier collapsed at the end of a particularly difficult pass. Their hearts failed them. The others did not bury them. They just kept walking, that was all. To turn round and give way to feelings was a waste of time, especially as they sensed wolves very close by. And every day they saw a horse, sometimes several, sink to the ground and die. Montefoschi said to himself that at this rate within a week not one would be left alive.

A merchant from Touraine disappeared down a crevice. One morning, two merchants were missing: their footprints suggested that they had turned back to Ishkashim. A mirage would perhaps be the final destination of their journey. Montefoschi dispensed words of comfort to those who were all too weary and terror-stricken. But the wind was blowing and only snatches of his fine words reached his despairing companions.

For these eleven haggard men braving the elements, the Pamirs were also the land where jealousies, resentments and hatreds were forgotten. They warmed each other. They squatted in the shadow of a companion in adversity. They ate of the same meat and the same dried fruit. They suffered aching backs from the daily trekking, altitude sickness, and stomach

cramps. At night they helped each other dig out the snow with a knife, then they huddled together in a hole like an animal's burrow.

The snow suddenly fell less heavily. But the cold intensified. As Montefoschi had predicted, all the horses eventually died. The wolves – Vartan counted about twenty in all – fought over the carcasses, sometimes boldly prowling into their camp. One morning they killed three yaks. The men seized their bows, and their arrows came down in the snow less than a metre from the wolves, raising a derisory barrier. A second volley of arrows doubled the quivering fence formed by the first. The wolves did not retreat. For a brief moment the silence was scarcely disturbed by the harsh breathing of the archers, who were blinded by the reflection of the snow. Then the wolves made a game of knocking the arrows to the ground. The game went on. The wolves dispersed when a third volley of arrows whistled through the air. While cries of victory resounded in the air, Tremer was dying.

Tremer lay in a not very deep hollow, sinking into the snow under the weight of his own frigid body. It would have been risky to try and lift him, for his limbs would have immediately become dislocated and shattered. Reduced to a purely phys-ical pain, the former guide no longer felt any emotion. When Jeremy picked him up in his arms, he was like a piece of marble that would crack under the effect of the frost. Tremer was unable to recognize his friend, his brother, and he cursed the enemy molesting him. He died after six hours' peculiar anguish. As he drew his last breath, the sky, the world's white-ness, the men and beasts, the living and the dead ceased to be reflected in Jeremy's eyes. And Jeremy then did some terrible things. He took a knife from his sleeve, with which he removed Tremer's eye-balls from their sockets, and he put them in a ring case. Next, he striped his friend naked and

dressed in his clothes. He pulled the fur hat on his head and wrapped himself in the fox fur and the wool coat, then rolled the other garments into a makeshift bolster and pinned it to his stomach with a rope that he tied round his waist. After examining the pair of boots, he decided they were more worn than his own, and he did not bother with them. All bundled up in this way, he looked like a grotesque, unfeeling ogre.

The Venetian had forbidden them to mount the yaks, to avoid tiring the animals, saying that an exhausted yak excited the wolves. But Jeremy ignored this ruling. To the merchants' amazement, Montefoschi did not contest this disobedience, and he justified his indulgence by confiding to Vartan that he felt sorry for the boy: it was now beyond his capability to blame anyone who fell into despair.

The horror they felt at the removal of Tremer's eyes awoke in the travellers an ancestral hatred. Insane legends that were told about Jeremy's people, in which cruelty and rapaciousness were the common themes, flourished again in their rare conversations.

There was no prayer, no sermon. They simply piled fresh snow over the body. And continued on their way.

The merchants followed in a line behind Montefoschi and Vartan, an unkempt and dejected troop, the last vestige of an army.

Silence was the sole companion of these men armoured in ice. The snow glinted and the sky was grey. Sweat dampened their underclothes, then made their skin smart, until it began to feel like cold rain on their body. Two small black lakes appeared between two chains of mountains, gleaming like a smooth pelt. These strips of ebony had a silver shimmer in the darkness.

There was no sign of the sun. Maybe it belonged only in Persia, Italy, Eygpt, the lands they had turned their back on, said Montefoschi, attempting to explain it. But Vartan replied that the sun always returned.

No tracks or animal droppings, no village in ruins, no other caravan in distress: just a granite sky, infinite snow and rocky heights. Was hell similar to this landscape? Was the fiery-red cavern depicted by artists and described in the sacred texts nothing but a fable? These were the questions the two men asked themselves. But what god or devil could reign over these plateaux and barriers? Perhaps they had found their way to an unknown hell where past and future had no meaning. An evil fate condemned them to living in the present, with this wind and these rocks. And there was no path.

Two of Hethum's soldiers fainted, and death overtook them in this state of unconsciousness. On the nineteenth day of trekking, the caravan numbered no more than eight survivors, eight automatons weakened by haemorrhaging. And in the evenings, they could barely warm themselves at a meagre fire, because they had no dry wood. The more the cold tortured these men, the more apparent their exhaustion, and the more deeply entrenched their desolation, the more Vartan accepted with profound joy this crossing over the Pamirs. Montefoschi's folly had brought him where he should be, where he was learning not to give way to despair, fear, frigidity, where he became other than himself.

A merchant who took refuge in a cave for the night was devoured by rats. Vartan was distressed by such a ghastly death, and at the same time delighted that any wild life should thrive in these peaks where he had thought there was no animal presence at all, since the wolves had not been following the caravan for several days now. Were rats the only inhabitants of this part of the Pamirs? Vartan scanned the rocks and precipices, for a glimpse of a bear or griffon vulture. But he was the only one to cherish this hope. As for Montefoschi, for the first time in his life he yearned for a settled future, with hearth, bed and livestock around him. This was because, like Vartan, he

allowed himself to believe that it was possible to escape the inhuman barrenness of the Pamirs, the glaciers, the monstrous rock heaps, and the implacable, everlasting silence.

One afternoon the sky tentatively turned blue and the sun shone. It was almost hot. But this change was insufficient to relieve the men of their ailments. The weakest were overcome with vertigo; they began reeling and suddenly falling to the ground.

Of his own accord Vartan curtailed his nights in order to wait for daybreak and be the first to discern the first glimmerings of dawn and see the splendour of this landscape as its wind-polished whiteness was made to shimmer. Some mornings, Montefoschi, emerging from a heavy sleep, would talk of mutton stew and well-prepared eels. Vartan laughed at him for these desires. 'I think that we'll content ourselves today with dried fruit garnished with a little ice,' he would joke ironically.

Together they would leave their snow refuge, and bury their face in a yak's coat, burrowing into the fur with their forehead until they encountered the animal warmth. They would remain like that for a few minutes, feeling happy. But for how much longer would there be yaks? Every day that dawned brought with it the unpleasant surprise of discovering that yet another one had died.

Like the beasts, Montefoschi sniffed the air, listened to the riffling of the snow in the gusts of wind, weighed up the dangers and calculated the chances of escaping them. Now the caravan's only guide, since Jeremy without Tremer at his side seemed as incompetent as could be, Montefoschi was afraid that the spring would bring avalanches. But he led his people with the same assurance as a herdsman driving his donkeys along a road in Castille or Anjou.

★

With a dullness in his eyes that never changed, Jeremy's gaze wandered over his ring case, his gloves and the ravines. At the least shying of his yak, he would screech, clutching its coat. With every movement he made, a cloth would escape from the bundle tied round his waist. If a fur slipped off his shoulders, he did not bother to pick it up. So he gradually lost the bulk of an ogre and anyone examining him would have noticed his thinness. Filthy, with the hair of a Gorgon, and lips brown with congealed blood, he was the twin of Hovsep when the robber used to haunt the Cilician countryside.

The death of his yak one morning stirred him from his apathy. He grabbed his huge mount by the horns and shook them violently. Half-starved, with a solemn expression on his face, he held fast, like a sailor clinging to the helm at the height of a storm. The yak's neck snapped. Jeremy let go of his tiller, and the heavy bovine head dropped forward. Then he stroked the woolly brow and congratulated the animal, like a groom with a horse that has won a race. Urine and dung escaped from beneath the animal's inert mass. The beast was purging itself of all pestilence before being reduced to a few bones polished by the frost. Jeremy opened his ring case: thanks to the temperature, the eye-balls had retained their pulpy softness, their rotundity, their agate brilliance. Tremer's eyes, those two perishable jewels, fascinated him. He took them out of the ring case, rolled them in his fingers, kissed them, raised them to his mouth and ate them.

It was evening and Montefoschi announced that in four days' time they would complete their crossing of the Pamirs. It was that same evening that Jeremy joined the Venetian in his snow-lined pit, making an effort to overcome a reawakened shyness dating back to his childhood. Montefoschi muttered that there was not enough room for three in their burrow. He and Vartan were already far too cramped to take in anyone

else, even the thinnest of the group. Jeremy was obstinate. Despite their protests he slipped in between the monk and the Venetian. He spoke at length in Montefoschi's ear.

'I'm the son of a rabbi,' he began. A rabbi who had been a close friend of Sa'ad al-Daula. In the course of evenings at the home of one or the other, or at religious services at the synagogue of Tabriz, Sa'ad al-Daula had taken an interest in the quiet and reserved sixteen-year-old that Jeremy had been. He thought he detected in the adolescent's air of wanting to rise above the crowd, above his equals and kings, the same ambitiousness that had brought him close to the throne of Arghun. So he showered him with presents and took him to the Ilkhan's palace. He became completely infatuated with this son of a rabbi. But Jeremy responded to his bounty with a guardedness that shocked him. Yet Sa'ad al-Daula persisted in bestowing countless gifts on him. He eventually made him his confident and counsellor. These two roles the boy fulfilled by the dim light of a candle-lit alcove, for Arghun's minister did not yet allow the boy to be seen in his company in the corridors and chambers of the Mongol prince's residence. In fact he was only waiting, before presenting him to the Ilkhan, until Jeremy had been licked into shape and was ready – for this was how Sa'ad al-Daula saw it – to reveal to Arghun, without diffidence yet diplomatically, the resourcefulness of his intelligence and his talent for frustrating conspiracies. Meanwhile the minister contented himself with observing his protégé, whom he saw as a reincarnation of his younger self. Beneath what he judged to be an affected naivety, the man thought he discerned a desire for glory, identical to his own desire for glory from his earliest adolescence. Privately, he told Jeremy of intrigues, and questioned him as to how he thought he would deal with them. The boy sometimes made some wise suggestions, yet without abandoning his lofty disdain.

Gradually he became restless listening to a man of power complaining about his spies and associates, raging against the

stream of supplicants that thronged to his door. Sa'ad al-Daula
punished him for his recalcitrance and inattentiveness by
soundly boxing his ears. This did not improve their relations.
Jeremy stubbornly refused to answer his patron's questions,
dreaming only of regaining the peace and quiet of his family
home, and getting away from this palace, where everything
bored and disgusted him.

Apart from their daily meeting, Jeremy's time was his own.
He would hang around the stables or the falcon house, and
wander through the streets close to the khan's residence. It
was there that he met Tremer. An unequivocal friendship
immediately sprang up between them. Tremer told him that
he was a guide, and so renowned at his job that Joram the
banker often hired him to accompany some of his friends –
wealthy travellers – on their way eastwards or to the North.
Joram was one of the richest men in Tabriz, which justified
his belief that he was destined by virtue of his wealth to play
an important role in Arghun's administration. But so far no
distinction had been conferred on him by the Ilkhan. Joram
knew the reason why: Sa'ad al-Daula was not a man to share
his power with anyone who was constantly discrediting him
with Arghun. He could think of only one solution to obtain-
ing the honours and position to which he aspired, and that
was to bring about his enemy's downfall, no matter how. He
worked at this by scheming, by spreading among the people
the worst possible accusations against Sa'ad al-Daula, and
inciting his murder. This is what Jeremy learned from the
mouth of Tremer himself, who moreover defended Joram, for
the minister's arrogance and vanity were intolerable to him.
He preferred the joviality and earthiness of the man he called
his lord.

It so happened that Sa'ad al-Daula had in his pay a signifi-
cant number of spies. It was they who revealed to him the
conspiracy. Tremer's name was cited among those of the con-
spirators. His daily encounters with Jeremy cast suspicion on

the latter. A horse dealer, some washerwomen and a skinner testified to having heard the two friends wish for the end of the minister's reign. The horse dealer added that Jeremy sneered at the idea of seeing his benefactor one day languishing in prison. To be mocked and almost betrayed by a boy that he had wanted to fashion in his own image was for Sa'ad al-Daula a crime of lese-majesty. Jeremy had deceived him unforgivably. And consorting with people involved in reckless intrigue was what condemned the youth in his eyes as rash, fickle and rather stupid.

The tales and truths that Joram had circulated about Sa'ad al-Daula bore fruit. The inhabitants of Tabriz now voiced out loud their hatred of the minister. Too much maladministration! Too many favours granted to anyone with ambition! In the face of this hostility Sa'ad al-Daula deemed it unwise to have Joram arrested, as there was a danger of making a martyr of him. But he had to quench his consuming thirst for vengeance somehow: what means could be employed so that he was not immediately identified as the person responsible? A slow-acting poison seemed to him the best choice. He arranged for one of his agents to be taken on as a servant in the banker's household, and a few days later Joram's glass was filled with a deadly wine. While Joram's henchmen languished in prison before being strangled, Tremer and Jeremy were more fortunate. Sa'ad al-Daula showed magnanimity towards them by condemning them merely to exile. He met Tremer in secret and made him swear never to return to Persia. He also urged him henceforth to set his life at naught by exposing himself to danger. Then he offered him, together with Jeremy, as a guide to Montefoschi. He told himself that sooner or later the Venetian would notice his former favourite's inexperience and dispense with his services, thereby forcing him to lead the life of a beggar. The day before their departure the two outcasts promised to help each other and to stand together even more than in the past. Once they set out,

Tremer would forewarn his friend of a pass, a succession of steep slopes, or ravines that lay ahead, in order to deceive the Venetian.

'But Tremer is dead,' murmured Jeremy, 'and I'm of no use to you.'

Montefoschi told him to sleep. During the night the young man died of an embolism.

The travellers no longer had the strength to carry their meagre bundles. At each halt, they jettisoned a little more. It was still possible to see the glint of a laminated thread in their ragged clothes or to detect a piece of gold sewn into the lining where it made the fur coat sag. These men looked like dazed fugitives. The sun beat down and the snow was powdery. The ice broke under the weight of a Persian. He fell into the void. His body rebounded several times on rocky outcrops and the echo of his fall was accompanied by a long cry. They leant over the abyss, but all they could see was a bluish gloom in which the cry suddenly broke off. A traveller from Baghdad remained standing at the edge of the crevasse. He refused to go on, and without trying to persuade him to resume their interminable trek, they left him there. The last surviving of Hethum's soldiers dug a deep hole in the snow one evening, lay down in it and never got up again.

There were two merchants still alive. One was from Tabriz, and the other was born in Carcassonne. They had had some disagreement in the Persian capital, and had been enemies ever since. But in the Pamirs' blinding whiteness, the breach between them was wordlessly healed. They shared the last of the dried fruit and at night enfolded each other to mingle their warmth. During the day they staggered on, or went bounding here and there like deer chased by a pack of hounds.

★

They completed their crossing of the Pamirs on one of the first mornings of March. The slopes were gentler and less high mountains dominated the plateaux. The plains were surely near. Besides, a few herds of wild goat heralded their proximity.

An astonishingly early spring suddenly triumphed, and the whole of nature gave way to unexpected confusion. Rain succeeded the snow. Rushing rivers glinted with their mantles of ice. The irrepressible surge of water created a tumult. Four men now waded through mud. Constant wetness made their knees seize up. From time to time, Vartan would whip himself with a cloth to get his blood moving and thereby maintain his faculties of observation.

Their provisions were exhausted. Four men dreamed of a big blazing fire, and licked their palms and fingers for food. Since they pissed and shat in their clothes, they made the small space in which they huddled together for the night stink. Having lapped up some slimy mud by way of a meal, the Persian and his colleague from Carcassonne swelled like leeches; they died in spasms, in scrubby grass blackened by frost.

Montefoschi's mind dwelt on the last moments of Jeremy, Tremer, the Persians, the Franks and the Armenians. He felt grieved to have so rashly led merchants and soldiers, guides and interpreters to a region where death was a daily occurrence. Unlike him, Vartan had already forgotten the dead and winter's torture. He kept his face turned towards the land of the Seres, his gaze fixed on the horizon, where the blue of the sky met the white of the undulating landscape. He was the first to spot a village in the distance.

The local peasants fell back before these two haggard beings, but they did not run away. At first they took them for ghosts

that had come down from the Pamirs. A scoffing old man calmed the crowd: ghosts never smell so foul, and they speak the language of the community they haunt or else through the voice of the wind and rain.

Montefoschi and Vartan asked for a goatskin of clean water and some food. Never had they experienced such a strong sense of being outsiders, and never had they felt so sure of being safe. The people laughed at the barbarous sonority of the words they jabbered, and since no one understood them they expressed themselves through gesture. But Montefoschi persisted in uttering wild words, words of hell, the only words equal to recounting what they had endured, the dreadful ordeal of the cold and their perilous journey. A woman touched his brow, eyes and mouth, and then examined the calloused palms of his hands, in which she saw the outline of the Pamirs and a wolf's head. A look of amazement filled her eyes. She told her family that these ghosts came from the graveyard of those who lost their way. She touched the man's brow, eyes and mouth again, and smiled this time, then she showed interest in Vartan, feeling his limbs, and in the hollow of his hands she saw the hostile immensity of the northern plains. Her smile faded. She turned her attention back to Montefoschi, and bared his chest, on which Kubilai's golden tablets gleamed. 'Who are you?' she asked.

# XXIV

In order to recover their strength Montefoschi and Vartan stayed in this village for a month, until the arrival in extremely mild spring weather of a caravan whose destination was Dunhuang, which they joined. It was doubly providential, for it allowed them to continue their journey without fear, and above all to get away from a place where they might well have met their death.

For the first three weeks of their stay they were an object of curiosity to the villagers. Perhaps the villagers also felt sorry for these two men, whom they thought to be even more destitute than themselves. But when Montefoschi offered topazes and rubies – which had been tucked into his belt – in exchange for new clothes, food, horses, and weapons, all this in anticipation of their departure, the population changed in its behaviour towards them. A feeling of envy now stirred in these uncouth souls without the stranger's resources, and the peasants said to each other that there was surely money to be made from these people. So they kept deferring until the next day any settlement of the price for the goods that had been asked for. This repeated delay alarmed Montefoschi, who realized what fate lay in store for them.

He and Vartan noticed that at night youths now watched the house where they were lodged. And during the day these same youths, as though by chance, accompanied them wherever they went. 'Why have they not already killed us?' Montefoschi wondered. 'What's all this leading up to?'

'Maybe they enjoy terrorizing us,' suggested Vartan. 'When they get tired of that, they won't hesitate to cut our throats.'

Then in the tiny room where they slept, Montefoschi taught the monk how to move stealthily and take a guard by

surprise, and how to plunge a knife into his heart in absolute
silence, for they had to think seriously about getting out of
this trap. 'Tomorrow night, we'll make our move,' he decided.
But they did not have to kill their guards: when they woke up
in the morning, a caravan had stopped in the village, and to
their surprise no one prevented them from approaching the
travellers, who agreed to take them to Dunhuang. When the
time came to leave, two youths brought horses, clothes and
provisions, and a patriarch pocketed their topazes and rubies.

# XXV

As they drew near to Kashgar, one of the guides painted a not very flattering portrait of the people they met on the way. He described them as steeped in incorrigible fatalism, accepting without anger or hatred invasions, bloodshed and the conquerors' scorn. The tone he employed was so authoritative that Vartan was almost persuaded of the existence of human beings without the slightest sense of rebellion, slaves in their souls, reduced to absolute submission by those who represent in this world the spirit of war and the fury of destruction. Yet some doubt prevented him from believing this guide's assertions. He thought it necessary to check them, for as a miniaturist, accustomed to capturing the tiniest nuances in a glance or the ambiguity in a gesture, it was inevitable that he should eventually feel some reservation about the idea that a man could respond to violence with the same behaviour all his life. So he carefully studied the peasants and villagers with whom he came into contact. His conclusions greatly conflicted with what the guide had said. He saw anger appear in the eyes of a woman and a desire for murder in those of a boy, he saw the crowd shudder with hatred as Mongol horsemen passed by. If he were ever to return to these parts, quite possibly he would be presented with the spectacle of severed heads, those of Kubilai's officials. Strangely, this thought comforted him. It proved that nothing is eternal, neither empires nor fears, and that, like these apparently passive people, the monk from Sguevra had a good chance of becoming a man who takes control of his destiny.

At Kashgar, he revelled in the sight of lemon trees, acacias, poplars and plane trees. He had been fond of orchards and woods since his childhood, when he had been able to

contemplate them at leisure on his father's estate. The pleasure of walking in the shade of the trees equalled his weariness of snowy expanses, stony ground and sandy wastes. He would slip into gardens, the way he used to as a boy, to steal a fruit. Several times he escaped a beating at the hands of servants outraged by his audacity. But on his last day in the town, he also had an experience that delighted him. As he was picking berries, a man called out to him, who neither brandished a club nor set dogs on him. On the contrary, he aired his views about theft and hospitality. Then he invited him into his home to take some refreshment. He was a Nestorian. From Armenia to Persia, the Nestorians had a bad reputation. They were criticized for being greedy, simonaical, ignorant, liars and polygamists. Narasai in no way answered this description. He was courteous, talkative, generous, regaling Vartan with little cinnamon biscuits and pastries with honey. And as our monk devoured one sweetmeat after another, Narasai murmured verses in Syriac or related a host of anecdotes about the town and its inhabitants. He had a dazzling turn of phrase, and a deeply rooted faith. When it came to saying goodbye, he hugged Vartan to his chest, wishing him a long life. This episode served as confirmation to Vartan that no man, be he Nestorian, Persian or Mongol, ever corresponds to the definitions that are peddled through the ages.

The camels progressed slowly. Accumulated grains of sand formed sharp crystal pellets that penetrated their hooves. The camel drivers said that these little pellets travelled through the horn of their hooves, cut into their flesh and entered their veins. They were then carried in the blood to the heart, where they accreted. An animal with its heart clogged with sand took days and days to die. In the Taklamakan Desert, there was distress in the gaze of beasts and men alike. Vartan saw the sadness in the yaks' eyes, and death.

<div align="center">*</div>

The desert waste turned from dunes, to a moving expanse of sand, to petrified forests. For two days, there had not been a breath of wind. Montefoschi cursed this furnace and the unknown god who created it. For how could the God of the Christians have devised a land so hostile to life? But all gods are the allies of fire and death, Arnaud de Roanne had said not so long ago. Since he had set out on this trek across the Taklamakan, these comments made by the doctor, and many more besides, constantly filled the Venetian's mind. He finally appreciated their wisdom or audacity. And so what was probably the true portrait of Arnaud took shape within him. He was an ungodly man, of integrity and sensuality, in short a scandalous and fascinating man, who, in the West, Montefoschi said to himself, would be suspected of heresy and condemned to be burnt at the stake. The Venetian was now obliged to recognize the doctor's intelligence, his freedom of thought, and the sometimes painful irony with which he interpreted and judged the world. As a result, he came to accept that this exceptional human being should have been loved by Hovsep. 'How could I have competed against him, with all my self-delusions? The die was cast from the day they first met. Why did I not understand that? Why did I let jealousy get the better of me? And how am I to redeem myself now?' Then Montefoschi suddenly conceived the idea of a book in which Arnaud de Roanne would have the place of honour that he deserved.

On the evening of the fourth day of their trek, Montefoschi, sinking to the ground at the foot of a dune, crushed his bag beneath his weight. He extracted from it shards of glass smelling of amber and jasmin. The flask of holy oil was broken. Vartan assured him that in Yarkand they would find apothecaries of great renown, who kept a rich golden oil in their dispensaries, and that he, Vartan, would bless it. Montefoschi sniggered. The original oil the Pope had given him had long

since been replaced. He had drunk every last drop of it in the Pamirs.

On the sixth day the oases at last were not just mirages. A phalanx of trees appeared. At sunset the grey-blue crests of poplars were outlined against the sky. The darkness was filled with singing and a murmur of conversation. There were towns. They slept at Yarkand, Hotan, Yutian. They met women and boys offering sensual pleasure. Then, cities half-buried in sand, men swallowed up by boggy ground, wells of brackish water, black rocks reaching like hands towards the celestial vault were all forgotten in a lover's embrace.

Several caravans made a stopover at Yutian on the same evening. So the caravanserais were packed. The travellers had to sleep six, seven, or sometimes more to a small room, or else crowded together in the bigger rooms. All the rooms smelt of camphor, sweat and urine. Overwhelmed with exhaustion, Vartan collapsed on a mat. The candles were snuffed out. Shortly afterwards, because he felt hands groping his waist, his stomach and his thighs, Vartan emerged from his dreams. At first he thought that someone was trying to rob him. But he was deceiving himself, and he knew it. He held his breath. These hands were not seeking gold. They were caressing him. Vartan pushed them away while at the same time making room for a body to lie beside him. A mouth kissed his mouth. He moaned and a hand muffled the sound. And his fingers too caressed and sought to lay flesh bare. For the first time ever he collected in his palm semen that was not his own. The body that lay upon him suddenly abandoned him, and melted into the gloom. The hours till dawn seemed long to Vartan. He dozed. With the first glimmerings of daylight, he realized that the nakedness of his groin was exposed to view. He shivered with cold, shame and fear. But already he was impatient for the return of darkness. God was less of a presence to him than

the most insignificant of men, for when the sun went down the most insignificant of men might prove to be a wonderful lover. In the light in which Yutian was bathed, he began to invoke the return of darkness with the encounters it brought.

That day a Seljuk merchant picked a quarrel with Vartan in the yard of the caravanserai. With scornful acerbity he declared that, in China, Vartan would be taken for a Mongol prince's catamite. Vartan responded by punching him, and they became locked in a fight witnessed by Montefoschi and four Persians. Vartan and the Seljuk wrestled for a long time in the dust. They sprang round each other and occasionally a fist would land on a nose, a cheek, a shoulder. Blood ran down their faces. They eyed each other up and down and exchanged insults with concentrated fury. More onlookers joined the few spectators. Then bets were made. As the fight went on, Vartan's body underwent a short-lived and amazing metamorphosis: all at once he possessed the hardness, resistance and weight of granite. Like Tremer in the week before his death, Vartan turned to mineral. But this transformation, rather than presaging his death, gave the monk a physical powerfulness that the worst brute might have envied. The Seljuk was overborne, his torso hugged by arms and legs of stone. His knees soon touched the ground, then his chest and forehead. Those who had bet on Vartan hailed his victory with shouts and cries. Logically the winner should have been at least as exhilarated as his supporters. Far from it. Vartan remained silent. He drew no satisfaction from his victory, no joy. He stared at the Seljuk and the sight of this man on the ground humiliated him. He became aware that conflicts and wars disgusted him, and that nothing justified the pleasure of conquest. Just as this thought became rooted in him, his limbs lost the properties of stone. A god, no doubt, had allowed this metamorphosis to take place, only to reverse it again, once his servant had learned his lesson. Was this one of those

experiences that proves that the Crucified Christ is alive within us? Vartan wondered. Yes, perhaps it was.

He helped the Seljuk to his feet.

Sounds of rustling fabrics came from the rooms of the cara-- vanserai. This was Vartan's second night in Yutian. He waited in vain for the stranger. He touched his genitals and licked semen from his fingers. That night he would not be satisfied with solitary pleasure. He went out into the courtyard; there too everyone seemed to be fast asleep. But a person might pretend to be asleep, might half-open his eyes as someone walked by and with the ghost of a smile invite him into his bed. So Vartan leant over every sleeping body, watchful for the flicker that would reveal a waiting lover. Every time, his hopes were met with snoring. He then decided to go walking the streets.

A harsh wind scoured the town. A heavy dust gathered against the walls. Vartan wandered through Yutian from sunset to dawn. At dawn he came across a boy who led him to a garden and there without a word took him.

# XXVI

The caravan spent five days in Yutian.

It set off again through red dust that caked everyone's clothes, a blood-coloured soot that gathered in the folds of their garments. This was in the heart of the Tarim. The white jonquil and the Kashmir iris were in bloom. Spikes of aromatic plants grew among the stones. The mists were sulphur-yellow, warm, noxious, and drifted about like an age-old airborne river. No one ever saw them disperse. They had swallowed up entire caravans, armies loaded with war booty, herds of animals with their herdsmen. At Yotan, a monk told Vartan that the Tarim was the only region of the known world that could not be artistically depicted. How was this nebulous mass to be conveyed? Artists had proved unable to reproduce on parchment anything but a yellowish smudge. But in the midst of these thick fogs, Vartan felt a yearning to paint the impossible, there and then. This turned out to be beyond him. To wield a paintbrush while travelling is difficult to say the least, if not totally unfeasible, as Vartan learned from painful experience. At every movement of his camel, his reed brush splotched the parchment with black or yellow, and both the painter's coat and the animal's neck were spattered with these colours. His travelling companions chuckled. 'Have you ever seen such a fool?' they said among themselves. And in the caravanserais, being able to concentrate on a work is tantamount to a miracle, given the constant confusion and all the coming and going. Vexed, indeed mortified, Vartan thought it best to give up the whole enterprise until Peking, where, he hoped, conditions would be more favourable to taking up his art again. Even at the ancient oasis of Niya, with that characteristic quietness of places about to be reconquered by the sands, he scorned his brushes.

★

The Niya oasis, much in use under the Han dynasty, had gradually been abandoned. It was now no more than insignificant ruins, earthen mounds, and stunted trees. As he tramped across the bleak desert waste dotted here and there with the indeterminate remains of a wall, Vartan found a broken-toothed, ivory-handled comb, polished by the wind. Like those young bloods of Tabriz who were endlessly preening themselves, he spent a long time untangling his hair. Totally absorbed in this task, he thought of a boy he had observed, in Tabriz it was too, dancing at the back of a room in the caravanserai, whom he had envied. To make himself look like this ephebe who played to an exclusively male audience, he reddened his lips and toe nails with the scarlet pigment he used for the bright-red robes of saints and dignitaries. And thus made up, he danced. He danced for an invisible assembly the slow and voluptuous dance of seduction. He danced in a petrified orchard, among trees the colour of white lead, raising their twisted branches beneath a purple sky. Then he rested, by some lacy poplars, slowly crumbling away, whose trunks creaked like masts. He sat on a tree stump, and for an hour or two was the motionless idol of an oasis that the world had presumably forgotten. He dreamed of the day when, in some field, or tavern, or wherever, before cowherds, heavy drinkers, a whole crowd, he would execute the figures of desire.

# XXVII

At Qiemo, Montefoschi and Vartan entered a town in celebration. They made several attempts to ask the inhabitants the reason for these festivities, and always without success. They received incoherent answers to their questions. They were told of an extraordinary killer plant, of some rebellious children who had saved the city by standing up to sceptical elders. The rest of the caravan were no more successful. They too were treated to strange explanations, and were ready to abandon their enquiries when Vartan came across a carter transporting an evil-smelling heap of what looked liked long slimy grass. The man was good enough to enlighten them as to the reason for the happiness that prevailed over the town.

Five or six days ago, he began, some children who bathed in the river daily noticed some aquatic vegetation, previously unknown to them, growing in profusion close to the river-banks. These algae wrapped themselves round their legs, waist and torso, but the youngsters easily extricated themselves. They decided to alert the elders of Qiemo, who merely patted them on the head, and smiled. Having already heard plenty of idle nonsense from the mouths of these children, they sent them home to their families. In any case, the truth of matters and the observation of nature were adult matters. The children returned to the river, where they noticed that in their absence the algae had extended their empire to the middle of the stream, and they now created a kind of virgin forest. They were swifter than wild horses, than Pegasus or the horses of the Apocalypse, and it became difficult to escape these innumerable serpentine filaments. The children went back to the wise men and described the river-born hydra. The elders finally bestirred themselves to discover that the plant's

crystalline green had turned brown, and was giving off a smell of shit. One of the sages threw this rotten stuff to the chickens, which disdained it. A whip came down three times on the children's backs. But their punishment did not discourage them from going again to the river whose surface was now a bank of emerald. The hydra had been busy. The children looked, and fell silent. They continued to remain silent in the streets and at dinner: they were afraid. And then fear began to seep through the whole town. In a single night, the hydra took over the docks. It was a vast fine-meshed net that covered masts, decks, and oars, crushing its wooden prey. It smothered some sailors and their captain. And the plant, as it was called, spilled over the riverbanks and struck out towards Qiemo. The population hastened to dig deep trenches to slow its advance. But the plant invaded the trenches, covered them over, and continued its progress. The heat of the sun made it stink like a charnel house. The wise men hurriedly assembled. Meanwhile the plant had swamped the lower part of town. One of the elders summoned the children. He knelt down before them, asking their forgiveness for his own incredulity and that of his companions. In a rush of contrition, he kissed their feet. The children granted their forgiveness, and the plant immediately withdrew, returned to the river, and disappeared into the mud.

The carter's audience heard him out in total silence. But as soon as he came to end of his tale, the travellers began speculating like gossiping housewives on market day. Children sense danger, like animals, they said. And what is wisdom if it remains deaf to the words of innocence? How can a man consider himself wise if he cannot believe in diabolical manifestations? Presumption and arrogance lead the world, a Persian concluded with grandiloquence.

Irritated by the fatuousness of these exchanges, Vartan slipped away before the end of this conversation. Montefoschi

found him much later in the courtyard of the caravanserai where they had chosen to stay. The young man was dancing before some travellers seated round him in a semi-circle. His limbs reproduced the sinuous movements of the plant and seemed to enfold the contours of a body, as if trying to smother it. Suddenly the plant that he embodied grew amorous. Vartan now mimed caresses, kisses, the passionate embrace. And his lips murmured words that are sometimes spoken in the throes of lovemaking. When he finished his dance, the spectators surrounded him and were lavish in their praise. One of them put his arm round him and led him off to his room.

Unlike the others, Montefoschi felt no desire for his friend. Besides, since Hovsep's death, the temptations of the flesh had become alien to him. Yet he was pleased to see Vartan adulated, courted, cossetted. At last the monk had stopped denying himself the sport of love.

The caravan remained at Qiemo for three weeks. The merchants could not bring themselves to leave a town where there was an endless succession of festivities. The religious authorities had given names to some of these – there was the Festival of Deliverance, the Children's Festival, and the River Festival – and they vowed to celebrate them every year in commemoration of the victory won over the plant. The caravan left Qiemo only when the banquets and processions came to an end.

The wolves around Qarkilik proved to be rather inoffensive animals, rarely sinking their fangs into human flesh. But like all their kind, they killed stray sheep and finished off ailing lambs. In five years only one little girl had fallen prey to these carnivores. All they left of her were her boots, a few scraps of her dress, and a pool of blood. The Tanguts described them as spirits that mainly fed on the cool evening air and fragments of stars that had fallen from the sky. The town of Qarkilik owed its reputation primarily to the hospitality and generosity of its inhabitants. It is true that they did not at all stint of their wine and lamb on the spit. They led invariably exhausted travellers into underground rooms where, they assured them, it was pleasant to relax, sleep, and dream. They were also famous for their lies, because the dampness that prevailed in these dark rooms was little conducive to rest, sleep and dreaming, as Vartan very quickly discovered. Clouds of sand flies attacked his shoulders and thighs, and he had to wrap his body in several layers of cotton and linen. This made him look like a mummy, with no sarcophagus to isolate him from the living. But there was worse yet: swarms of mosquitos served as a prelude to other discomforts. There were scorpions lodged in

the slightest crack in the walls; hordes of red cockroaches, fleas and lice had taken up residence in the floor matting. Vartan, like all previous tenants, chose to go and lie on the sand, outside in the moonlight. Rarely victims themselves of this wild life equipped with elytrons, mandibles and stings, the inhabitants of Qarkilik were amazed by the fears the vermin excited in travellers. And they would emerge from their catacombs in the morning fresh, cheerful and hungry. Vartan credited them with a supernatural control over beetles and gnats, spiders and centipedes.

This proliferation of insects did not tempt them to extend their stay in Qarkilik. And they resumed their journey to Dunhuang as quickly as possible.

For nearly a month the caravan skirted the desert of Sinjiang. They made their way through what seemed like a deluge of fire, so intense was the heat. A man who fell from his horse from exhaustion was entitled to a few drops of stale water from his leather water bottle. Evil spirits had lived in this desert since the beginning of time. The tribes of this region feared their malice more than the bite of a viper. The movements of these spirits gave a shimmer or pearly lustre to the air. And as they passed, the sound of the wind would turn into a song. They were the will-o'-the-wisp that follows the traveller, and when they gathered round campsites in their thousands, the desert would be suddenly imbued with the scent of amber, jasmin and myrrh. They fed on the aroma of a meal, the smell of fried food, or the reek of poor quality wine. They were wide-ranging in their tastes. At certain times they imitated brilliantly the voice of a Persian, a Seljuk, a Mongol or a Frank. This talent had dire consequences for the men travelling to China. A laggard would think he could hear the desperate cry of one of his companions. He would go to his aid, never to be seen again, having lost his way in the sands.

The spirits of Sinjiang filled the day – and sometimes the

night – with the noise of clashing armour and the sound of drums and cymbals. These were occasions of invisible combat. But their murmurings had no effect on the merchants. Once again, Montefoschi used cunning: he advised the forty-three men to put cotton pads over their ears, so as not to hear the jinn. And the ruse worked. The demons shouted themselves hoarse, to no avail. This setback reduced their powers. One morning these invisible creatures materialized and dried up in the sunshine. A god had deprived them of their immortality. Occasionally, a traveller would notice a pile of ashes in the sand, which the wind could not disperse: it was the remains of one of the spirits of Xinjiang.

And, like the Pamirs, Tabriz, Ayas and Sguevra, this desert became a memory for Vartan. They were entering the ancient kingdom of the Tanguts. In Dunhuang, there were temples and monasteries everywhere. Tamarind groves grew on the outskirts of the two towns. Beyond their outlying districts, marshes were plumed with reeds. Their continual rustling could be heard from a great distance. For the merchants they heralded the city and its riches, and the sleeping mat ever welcome to aching limbs.

As the guides had told Montefoschi and Vartan beforehand, the caravan was not continuing beyond Dunhuang, for Kubilai – on a whim or suspicion, who could tell? – had refused these travellers a pass that would have allowed them to procede further into the Mongol empire. The Venetian and his companion had to wait over a month for a caravan to pass with total freedom of movement throughout the Chinese territory.

During this enforced sojourn, Vartan became friendly with a family who often invited him to share their meals. His hosts spoke Tangut, which he failed to master. He could only memorize the words used to ask for water, wine, another

cutlet. He wished he could choose from among his table companions one who would teach him the basics of the language and be his lover for the duration of his stay, but he did not fancy any of these cheerful gluttons. So he would make some excuse or other to get away, and go wandering about town, wherever his encounters might take him.

Montefoschi did not take part in these feasts. He drew up a list of the key events in his life. He had lost interest months ago in knowing whether his warehouses in the Crimea were prospering, and he had not sent a single message to his administrators. The eminence and immortality of his name no longer concerned him. On the other hand, he was now obsessed with compiling an account of his journey. He longed for quiet and monotonous days in which to write of the ambitions that had died in him, of his derisory dreams, and the tale of a passionate love.

# XXIX

Then it was time to leave Dunhuang.

The caravan that Montefoschi and Vartan joined was going to Kanchow.

In the province of Kansu, the horses ate a poisonous herb that had the surprising effect of causing their hoofs rapidly to disintegrate, and their exposed feet bruised on contact with the stony ground. The animals were lamed, and as this slowed their progress, the men wondered if they would ever reach their destination.

Vartan soon tired of this region where, it seemed, jinxes flourished. But was it not always so in the countryside, forests and mountains? Heaven knows why, sorcerers and spirits of the earth had less influence over the towns. So, like the others, Vartan lost patience with their slowness in crossing this region and dreamed of finding himself within the walls of a city that would protect him from the hostility of nature and its animal population.

Two days' trek from Kanchow, the caravan stopped for the night in a village where some Uighur peasants bound for Peking were bivouacked. They were hoping to be able to present Kubilai with a breed of red-crested ducks with dark-green crops. As a result of cross-breeding, the weight of their fowl was twice that of a normal duck, and the flesh had more flavour. Accompanied by their womenfolk, these peasants eager for honours and recognition were therefore relying on the succulence of their poultry to gain them the rank of steward of the imperial farmyard.

One of the women kept casting glances at Montefoschi. At dawn, she overcame her diffidence. As soon as she sat down

beside him, she drew eighty-three small circles on the ground, which, she said, represented each of the eighty-three people he had hated, loved, despised or admired during his lifetime, and by the power of words, she went on, he was going to be able to wrest them from that oblivion into which the dead nearly always sink. Thanks to him, future generations would, in their turn, hate, love, despise or admire people who were long dead. But once he had completed the eighty-third portrait, he would succumb to a fever that would suddenly turn him into a man with no memory.

To thank her for her prediction, Montefoschi offered her a precious stone, which she refused.

'I've no need of anything,' she said, 'for my family and I will receive from the hands of the khan more riches than we've ever dreamed of. Keep the stone for now. One day, on an island, you will sell it, and the price you get for it will assure you of a life with no anxiety for the future. It is on that same island that you will close your eyes, on a world whose chaos and beauty you will have known how to describe.'

# XXX

At Kanchow, one morning, the merchant travellers took their leave of Montefoschi. Some were returning to Persia, others to Lesser Armenia. Proud and quick to take offence, with their chest thrown out and a knife in their belt, they looked like warriors going into battle. Crinkling under an Armenian's robe, close to his heart, was a letter from the Venetian addressed to one of his cousins who was running the warehouse at Sudak in his absence. Vartan had written it at his dictation. The letter was short: fourteen lines, informing the recipient, with the dryness of a legal document, of the death of his relative. Nine sentences explained that fever had carried off a man reduced by the perils of his journey to a state of total poverty. Montefoschi asked Vartan to give him back the will he had in his possession, and he tore it up. He justified his action thus: being my heir would have obliged you to return to the Crimea and perhaps even to Italy, to settle my estate, when your destiny is to turn your back on the West, for good. For I believe that you were born to live in the East, to explore its treasures, to love the men of these lands, and win their love.

Through one of his officials, Kubilai made known that he refused permission to Hethum's ambassador and the monk to continue their journey, at least for the time being. It was said that as the emperor aged, he became more Chinese in his ways and, like all Chinese, wary of strangers. Perhaps he no longer remembered having lately received the Venetian in his palace, and having then appointed him his messenger to Pope Nicholas IV. Be that as it may, his spies kept them under surveillance as if they were ordinary merchants. They spent eleven months in Kanchow.

★

During their compulsory detention, Montefoschi occupied a room in the quarter specially reserved for foreigners. He went out little, eating and drinking to excess. Living this reclusive life, he put on weight, dozing for long hours during the day, and in the evening at last devoting himself to the account of his adventures. Vartan shared his room for a while, then complained of the cramped conditions and finally decided to move out. Montefoschi had taken on, as his porter, valet and cook, a talkative young Uighur inclined to gossip. One day the young Toghril turned up in a state of rare excitement: he had just been told a story that was going round town, of a Mongol thief, who had died, pierced by an arrow on a horse sweating blood. Montefoschi was to hear this story many, many more times. Depending on the narrator, the thief would be Persian, Frankish, Armenian, Egyptian or Mongol. So, within only a few months of his death, Hovsep had acquired legendary status. Montefoschi decided that day that his book would open with a description of mists from which would emerge a god of love steeped in the crimson blood of all ill-fated lovers. The work would thus bear the stamp of the tragic and the divine.

Vartan returned only twice in eleven months to see Montefoschi. He had the impression during his visits that they had come to a parting of the ways. The man showed no interest in him, was even rude towards him. He sighed and yawned to show his impatience with their too protracted meeting. Toghril stood there, by the door, throughout their desultory conversation. Vartan, whose feelings were hurt by this bewildering behaviour, decided not to visit him any more. He regarded Montefoschi as a friend who had betrayed him, and he no longer wanted to see him. And the man gradually receded into his past.

★

Vartan grew bored in Kanchow. Or so he thought. Actually, beneath a veneer of boredom, he was gnawed with anxiety.

As soon as he learned of Kubilai's decision to detain them in this town, Vartan vowed to devote most of his time to his illumination work. This turned out to be a pious hope. With paintbrush in hand, he let hours slip by without being able even to sketch the outline of a saint or the form of a bird. And if he did finally trace a line on the parchment, it was a wobbly line. Biblical scenes, Christ's miracles and passion no longer inspired him as they used to in the scriptorium at Sguevra. It was something else that he wanted to paint. But he did not know what. No doubt, the impossible, those mists of Tarim that defied artists. He tried to reproduce them as he still pictured them in his memory. The result was humiliating, and he fled his room into the streets of Kanchow.

Through his frequent roamings he came to know the town well. He also came to prefer certain districts, so much so that his footsteps always took him there. There was one place in particular that enchanted him, especially in summer. And yet there was nothing remarkable about it. In what way could a tree, growing in the corner of a little square, more often than not deserted, seem so out of the ordinary? To find out, it had to be seen in the early afternoon, when a triumphant light transformed it, gilding it with every shade of gold in creation. Yet the tree in its vermilion glory made less of an impression on Vartan than at nightfall. As the light lost its intensity, the golds mellowed as if an infinitely sheer veil covered the foliage and trunk. The tree seemed to tremble in a breeze. The plant's gentle quivering was what overwhelmed Vartan. That was what he had to paint. But he became dejected at the idea of expressing the intangible. He felt that he was bound to meet with failure. And as darkness fell, his enchantment gave way to rising despair.

One evening as he was about to leave, he sensed a presence

behind him. He turned: a man was smiling at him and Vartan thought to himself that this extremely enigmatic smile would be as difficult to capture as the tree. If the man noticed his perplexity he gave no sign of it. He introduced himself. His name was Kao Hsuan, and like Apollonius of Tyana he spoke all the languages of the universe.

'I am a painter,' he said. 'And I have painted this tree that you have been contemplating for so long. For I've been here all this time, and saw how enraptured you were. You and I are the only ones in this town to take any interest in it.' He paused, then made a suggestion: 'Would you like to join me for supper?'

As he was curious to know how Kao Ksuan might have represented the sublime, Vartan accepted.

But at his host's house he hardly touched any food, he was so beside himself with impatience. The Chinese artist kept his guest on tenterhooks by serving him with deliberate slowness. He seemed to enjoy this game. And when Vartan pressed him about being shown his work, he piped, 'Yes, yes, in a minute,' then continued chatting as if he had forgotten what he had just been asked. Vartan's exasperation was at fever-pitch, when with the same smile that had been on his lips in the square, the man went over to a chest from which he took out a sheet of paper. Vartan made as if to grab it. Whisking it away, Kao hid it from view.

'Why in such a hurry?' he mumured. 'Why? Is it so painful to wait? Is it beyond your capability to master your emotions, to temper the ardour of your desires? Is it not ridiculous to behave so brutishly in order to lay hands on a piece of paper? Can getting yourself so worked up be any preparation for deciphering that which is imperceptible which belongs to the realms of the ineffable?

'Forgive me,' said Vartan simply.

'What a strange choice of words,' sighed Kao Hsuan, 'yes, a strange choice of words in response to what I said. You

haven't offended me. I was referring to you, I was talking of how to apprehend the beauty and complexity of what is around us, that's all.' As he uttered these last words, Kao Hsuan handed Vartan the sheet of paper.

A few confidently drawn lines gave an intimation of the tree rather than reproduced it in detail. Nevertheless, it was certainly what our monk had so often scrutinized, contemplated, loved. The foliage rendered in three uninhibited brush strokes rustled in the wind that so often swept the square, and the febrile simplicity of the sketchy trunk had such immediacy that Vartan, thrilled by it, multiplied the tree *ad infinitum* and suddenly found himself in the heart of forest, where all is shadow, whisperings, mystery. The tree occupied the bottom left-hand corner of the painting. The space between the tree and a mountain, of which the artist had suggested only the peak, was of the whiteness of a cloud, with the merest trace of black veining here and there. It was spellbinding, enrapturing. Did it offer evidence of invisible worlds that, in the confusion of every-day life, could not be detected? Without a doubt. Vartan remained silent for a long time. Then he admitted to Kao Hsuan that he too was a painter. And Kao Hsuan asked him to bring one of his works the very next day. But Vartan never returned.

Back in his room, he poured his pigments on the ground and trampled them under foot, smashed his paint-mixing saucers against the walls, and broke his paintbrushes. Once his rage had passed, he opened Leon II's Bible, and spent hours studying each face, the groups of figures, every landscape. Nothing had the immediacy of the whiteness of that mysterious, apparently motionless cloud poised between the tree and the mountain. How dare he set to work again if the result was to be such a lack of expression in the eyes, stiffness of the bodies, and naivety in the representation of nature and animals? Were the monks of Sguevra, the aristocrats of Sis, the people of

Lesser Armenia, and their king, so blind or uncouth then that they could admire a work devoid of substance, intelligence, beauty? All he would ever be was a moderately gifted student elevated by chance. As for conveying through a tree, a cloud, a mountain the very essence of the world, he preferred not even to attempt it. He had neither a brilliance of touch nor that genius which consists in being able to convey empty space. And his freedom from any delusion advised him to abandon the paintbrush for ever. One day, perhaps, he would be blessed with inspiration again. Then with a single brushstroke he would try to capture Kao Hsuan's smile.

# XXXI

Finally Montefoschi received permission to proceed to Shang-tu, Kubilai's summer residence. Caught up in the enthusiam of writing his memoirs, he did not immediately convey the news to Vartan. And when he came to describing his stay in Kanchow, he began to dream of the island the Uighur peasant woman had referred to. One morning, he made up mind: he would take to the road again and seek that island, and Toghril would accompany him.

When a little girl brought the imperial permit to Vartan, the Venetian had already left Kanchow.

In his friend's bedroom Vartan found the last traces of him: a phial supposedly containing holy oil, the golden tablets, a purse filled with pearls and sapphires, the letter from Nicholas IV and the one from Hethum II, both addressed to Kubilai. The memoirist had pinned up on one of the walls of the room a parchment copy of some pages from the account of his adventures. Vartan began reading, when suddenly the text became blurred. He closed his eyes, and reopened them. The mist had cleared. Then he was able to read his future: 'Vartan Ovanessian reached Peking, where he made a friend who took him beyond the known world.'

# XXXII

It was September when Vartan reached Shang-tu, where a bitter disappointment awaited him: the emperor had left his summer residence and returned to Peking a week ago. He despaired of ever being able to converse with Kubilai within the emperor's lifetime, and this led him to think of his own death. But he refused to succumb to morbidity. Out of loyalty to his king, he had to carry out the mission that had been entrusted to him: to set down at Kubilai's feet the holy oil and Leon II's Bible, to be the advocate of a religion and a culture. Then he would surrender to whatever course events might take.

Though impatient to reach Peking as quickly as possible, he was made to champ at the bit, for his travelling companions, at least so it seemed to him, took pleasure in prolonging every stopover. At Etzina, they spent several days hunting with falcons; in a valley with a river running through it, they developed a passion for pike-fishing, and this new passion lasted several days more. Vartan went from exasperation to anger, from grumbling to cursing. They were trifling with him! But his bad mood passed as if by magic when he saw the merchants basking on the riverbank semi-naked. How could he resist such a sight? He sat among them, forgot his grievances, and paid heed only to his desire.

And now Vartan was in Shang-tu, the town of a thousand temples. The monks, wiry and sprightly little men were attended by a smell of carrion and pigsty. From one of them, he learned that their basic diet consisted of a gruel of semolina and bran, except when a condemned criminal was executed, for by tradition the body was given to them. They would dismember it and, once it was cut into pieces, cook it. After

the monk had told him of this abominable practice by his community, Vartan did not want to stay in this city any longer than necessary. Walking through the streets, he felt as if greedy eyes were resting on him, and he was suddenly afraid of ending up in a cooking-pot. As soon as he told the fellow travellers that cannibalism was condoned here, they packed their bags.

Vartan entered Peking on one of the last days of September. But a further twelve months passed before he was received by Kubilai.

# JEBE'S STORY

# XXXIII

At last the day came when the emperor deigned to meet him.

Vartan walked along endless corridors and passed through more than a hundred doors, preceded by a chamberlain and escorted by archers. The only sound was the rustling of silk garments and the clicking of sabres. The monk was not apprehensive about his audience with Kubilai. He carried within him Montefoschi's ambitions and on his face the hardened expression of Hovsep as he plotted against Roger de Narbonne; he also displayed the supreme calm of Arnaud de Roanne at the bedside of dying men, and his own pride in successfully crossing the desert wastes of snow and sand. For brief moments, he thought of Marcos Traboukis, and the first thing that always came to mind about his friend was how love, nothing but love, had claimed his whole his life. According to Montefoschi's writings, he too would experience this, and the idea of it exhilarated him. So it was with a certain confidence that he entered the room crowded with ambassadors. He prostrated himself before the khan.

After Kubilai's words of welcome and friendship were translated by an interpreter, Vartan was given permission to rise, and was able to contemplate at leisure the Emperor in his majesty. At a signal from a chamberlain, he realized that he was now supposed to present his tributes to the smiling conqueror. He handed to him Leo II's Bible, then opened the phial of oil and offered it to Kubilai, saying untruthfully that this liquid had been blessed by the Pope. But of what significance could this be to Kubilai? The emperor rubbed a few drops between his palms as one does with a perfume. Although the oil had turned rancid, the khan sniffed it with evident pleasure. He expressed thanks for the gifts and the

audience was over. Twelve months is a long time to wait for five minutes of courtesies, was Vartan's conclusion.

A feast followed, in the course of which incredible quantities were consumed of wine made from vines recently planted in China, spirit distilled from rice, mead, barley beer, and kummis. Like his subjects, the khan drank to excess. His doctors had warned him of the debilitating consequences these excesses could have on his constitution, but he took no notice of them. As a result, his legs were all swollen, his blood thickened, and his heart thudded violently in his breast. But Kubilai feasted, unperturbed, in front of the tables set up for his womenfolk and captains. There was general drunkenness. To Vartan, it was like being at an inn in Ayas or Tabriz. Already for some time now Kubilai had been slumped on his throne, offering his courtiers the image of an exhausted old king. Nevertheless, no one would have presumed to be disrespectful in any way, or to mock the man who claimed to be master of the world, for the sovereign's eye was always watching them, penetrating their secrets, judging them. Under that cold eye, everything with which Vartan had steeled himself evaporated: Montefoschi's ambitious ardour and Hovsep's harshness of attitude immediately melted away; gone were the self-control and patience that were Arnaud de Roanne's bequest to him; even his natural pride deserted him. All he was left with was his belief in the Venetian's prediction.

# XXXIV

The Tajut tribe had become the elect. It was with that tribe, among others, that Genghis Khan had celebrated his earliest victories, and shared the spoils. This distinction had made its members the aristocrats of a new empire. They were called the Pure, or the Sons of Light. Jebe was one of them.

Eight months before the audience granted to Vartan, Jebe had witnessed the public humiliation of his father, Jiruki, at Kubilai's behest. The scene had occurred during the Calends, ceremonies that took place during the month of February. Feasts were held at which the best Mongol warriors asked the khan for one or more fiefdoms as a reward for their latest exploits, and their requests were satisfied. But Kubilai dismissed Jiruki's request with a wave of his hand, even accompanying his refusal with a look filled with bitter scorn and an anger that augured ill. As the emperor was not a man to justify his decisions, Jiruki was left in the dark as to the cause of this snub.

   Disgrace usually ended in execution. This time, however, it did not. Long after Calends, Jiruki was still waiting to be arrested, but it seemed as though his existence had been forgotten. He would rather have had his head cut off, than endure this treatment as an outcast. He fell into despair and fretted. To see his father suffering in this way radically altered Jebe's character. He became touchy, abstracted, and sometimes argumentative. In his heart of hearts, the young man was committing a sacrilege: he was judging the emperor.

In October, Jiruki took a dramatic decision that was later to prove fatal for his son: one morning he would slip away, on his own, and head for Karakorum, formerly Genghis Kahn's

capital. He wanted to go north, to the outskirts of an ancient forest where his forefathers were buried, far away from an ungrateful master. Before his departure he inspired Jebe with nostalgia for a time when all the laws of Genghis Khan were respected. He too took the liberty of judging Kubilai by lamenting that a Mongol emperor could become so excessively Chinese in his ways as to neglect the customs of his people. They should beware, or this scandal would spell the end of a world. The father deliberately sowed in his son the seeds of revolt, for a dream had told him that Jebe would gather an army in China that was to overthrow a kahn who had betrayed the spirit of his ancestors. Since his humiliation, Jiruki no longer had the strength to fight, only the strength to die. He fled from Peking, as he had planned, with the first cold weather of November. His sudden disappearance, he correctly assumed, would immediately breed in his son the suspicion that Kubilai was responsible for it. Then Jebe would not hesitate any longer to avenge his father.

To everyone's amazement the imperial guard did not seize Jebe from his home to make him confess under torture the details of the conspiracy and the place where the fugitive was hiding. Oddly, he was able to move around Peking at will. But one morning he was surprised to be served by valets and chambermaids who were strangers to him. Their discretion, obsequiousness, and perfect training were the indisputable hallmarks of Kubilai's servants. His isolation began. It became total when Jebe's family and drinking companions declined his invitations via their servants. Laughter, revelry and dances were now a thing of the past.

This ostracism brought Jebe closer to his wife, Sogotai. If the love he had once felt for her did not revive, the man nevertheless took pleasure again in lying down beside her, caressing her, possessing her.

But consumption was taking its toll on this meek, gentle,

and devoted wife who was subject to visions. One of these revealed to her that Jiruki was making for Karakorum. She wasted no time in telling her husband. 'I don't know whether he is being followed,' she said. The couple took care never to mention Jiruki in front of the servants. But after the sun had gone down, when they retired to their bedroom, Sogati would scatter sticks on the ground, by the light of a torch. And pointing to each one of these pieces of wood, she would say: 'This is the desert, this the steppe, this is tiredness, fear, hope.' Then she had her vision. 'He is alive, and alone, and approaching sacred lands,' she murmured. One evening she added, 'This is the town and this is the end of the journey. Let us rejoice, he has reached his destination, he is happy.'

That night, after making love to her, Jebe promised his wife that he would make her the new empress of the Mongols.

Before her marriage Sogotai had spent a lot of time in the company of shamans, and her father was a famous storyteller. Because Jebe divided most of his time between the court, carousing, and military campaigns, she had rarely had the opportunity in recent years to share her knowledge with him. But now that Kubilai no longer laid claim to him, and his friends and relatives had deserted their home, she spoke to her husband of Tengri, god of gods, of the congress between a blue wolf and a deer, their people's ancestors, and of the conquests of Genghis Khan. He fell asleep in wonderment, dreaming of being the warrior who would own one hundred thousand head of cattle and three hundred thousand horses; he wanted to be master of the world.

Sometimes, when he woke, Jebe recalled the face of an Armenian who had appeared before the khan as an envoy of the Pope and of the king of Lesser Armenia. That was the last occasion on which he had entered the imperial palace, a few weeks before Jiruki's disappearance. That same day he had

heard merchants avowing that the Armenian was a magician, that he had transformed a caravan into a serpent of fire, that he had crossed the Pamirs wihout suffering from the cold, and the desert of Sinjiang without undergoing the torments of thirst and hunger. Jebe yearned to meet this man, whose powers he could perhaps use to reduce Kubilai's kingdom to nothing.

# XXXV

The quarter where foreigners resided lay on the outskirts of Peking. One morning Jebe made his way there. As soon as dawn broke, Sogotai watched with sadness as her husband dressed in princely attire, as if he were going to court. She knew that a face haunted him, and that he was going in search of a man who would take him away from her forever, for the reeds had warned her that on this very day Jebe would meet a monk from the West whom he would love. It was Tengri who had given her the ability to commune with flora and fauna, and invested her with the power to penetrate the secrets of things and of human beings. Left by herself, she prepared an infusion of various plants, which if drunk at the same time for forty days, would guarantee certain death. At the first mouthful of this brown potion in which some tiny purples leaves were steeped, her cheeks turned ruby red, and her body shuddered. Sogotai braced herself as though to resist a strong wind. A fieriness ran down her throat. And when the fieriness was extinct, she wept hot tears that made her eyelids smart. Then, restored to calm, Sogotai thought of her three still-born children, of Jebe's duty to father sons, of her time on earth which would be short, of the love that gave her substance. She was already looking forward to her daily rendezvous with a little pot with a few tiny purple leaves floating in it.

Jebe had just passed through one of the twelve gates of Peking. And this capital which he had so often roamed with pleasure, today he hated. Under Kubilai's influence it had become the symbol of the Mongols' abandonment of their wandering, and consequently of conquest. The mere sight of these warriors, who used always to be out in the open, and who now

for the most part preferred life at court to life in the saddle, was enough to confirm the truth of this. They had all gone soft. But thanks to him, Jebe, these times would come to an end. He would restore to every one of them the taste for fire and sword. Life would again be harsh and exhilarating. Had he had a torch, he would have set fire this very instant to these dwellings, these warehouses, to the whole city.

He wandered for a long time through the districts of Peking, before finding the caravanserai where the Armenian was staying. Without announcing himself, he entered Vartan's room and found him in bed, with rouge on his lips, and the golden tablets lying on his bare chest. He was asleep. Jebe stayed at his bedside without uttering a word or making any movement. This sleeper who troubled him must be like those boys, sons of conquered princes, whom Kubilai sometimes attached to his retinue and whom he elevated for a short time to the rank of favourite. Jebe did not condemn this practice. He even imagined himself, already emperor, accompanied everywhere by this man who, as well as being his favourite, would scare off his enemies with his sorcery. He stepped forward and lightly touched the naked shoulder. This slight contact was enough to waken Vartan, who did not seem unduly surprised by the presence of this stranger. But instead of caressing him, this man began to talk. As he did not understand a word of what the man said, Vartan called a valet to go and find an interpreter. Jebe did not wait for the interpreter to arrive. Trusting to impulse, he revealed his ambitions and confided his dreams. When the interpreter finally turned up, Jebe used him to announce that he would be back in nine days' time, and that next time he would not talk so that he could hear from Vartan's lips the story of his adventures. Then he departed.

The day before his second visit Jebe was summoned by

Kubilai. Sogotai consulted the stars and declared that false-hood would preside over the meeting.

In the room where the emperor usually debated and argued with his generals and the ambassadors of every kingdom of the globe, Kubilai was alone with Jebe, telling him of Jiruki's death. 'There are roads fatal to traitors,' he said. A troop of soldiers that he had sent in search of the fugitive – by what other name could such a man be described? – had captured Jiruki at the gates of the town of Ejin Qi. Dazed with weari-ness, he had offered no resistance to the soldiers. That imbecile – there was another term that perfectly described him – who had lost his way in the wind and cold, was decapi-tated as soon as he was captured. He would have no burial. His bones would be left to whiten like those of the camel, the yak, the wild ass. Kubilai raised his voice: 'Your father was plotting, I know. And will you follow in the footsteps of that scheming coward? You have nothing to say for yourself. Very well. If you defy me, know that when the time comes I shall strike you down, and your punishment will be exemplary. Yes, I shall crush you, son of Jiruki.' As though exhausted by his anger and threats, the khan suddenly fell back in his throne. And with a gesture of finality, he ordered an impassive Jebe to leave his presence.

In the streets of Peking, Jebe spoke in a low voice to an invis-ible interlocutor, his father. He was still alive – he refused to believe otherwise. Nothing and nobody could persuade him of his death, not even the emperor. Besides, Jiruki had reached Karakorum. Sogotai had said so. Had she ever once misinter-preted her premonitory dreams, her visions? No, never. He had faith in her, in her gifts, her integrity. As he extolled his wife, now damp with fever and yellow of complexion, a brown fluid smelling of rotten hay flowed from between her thighs. Her flesh wasted away and her skin became so

171

transparent that her heart could be seen to beat wildly. She might have been taken for a glass effigy. She sank into an ineffable inner darkness. She was dying, but no longer suffering. Finally she expired and it was at that moment that Jebe had the impression of being kicked by a wild horse.

# XXXVI

Sogotai's death deprived Jebe of the unstinting advice that she gave him, which tempered his rebellion, anger, and need for vengeance, all the hotheadedness of a young man little inclined to patience and restraint. Now left to himself, he was in danger of acting rashly, without discrimination, of stupidly provoking Kubilai and drawing his ire. But luckily there was Vartan, to whom he returned every day, and who, by his gentleness, feyness, and feminine graces, distracted him from the decline of the empire and the need to halt it.

The two friends taught each other his own language, explored the vocabulary of merchants, shepherds, warriors and lovers. Jebe took delight in describing in Armenian grassland and horses, the green of gentle slopes, the blackness of sparsely-growing trees. He vowed to make a warrior of Vartan and, to please him, the latter promised to learn the art of cutting off heads and reducing towns to ashes. But he immediately regretted his promises: war disgusted him, violence terrified him. They were not of the same breed. By refusing to become a soldier, he could only be a disappointment to Jebe. Then what would become of their love? What unknown world had Montefoschi been referring to in his manuscript? And to what fate was Jebe leading him? He shrank at the thought of having to provide answers to these questions, and he chose to leave the future obscure. And in any case, was it not enough to enjoy the present?

Their close relationship was interrupted for several weeks when Kubilai invited Vartan to visit the town of Hangchow, so that when he went back to Lesser Armenia, the illuminator would be able to tell his king of the wonderful sights the

most beautiful city in the kingdom had to offer. The emperor also urged him to note down his comments on the state of river and maritime commerce, the organization of food supplies, the laws regulating daily life. The emperor valued an outsider's view, for it allowed a comparison of two ways of looking at the world, which is sometimes a source of enrichment.

The very day after his arrival in Hangchow, and every follow-ing day, an officer took him to the port, then to the markets, and finally into the establishments of the most wealthy traders. Vartan mentally noted a thousand details, a thousand oddities, a thousand treasures on display, and in the evening he recorded them in writing on a silk scroll. But he was not Montefoschi. Owing to a lack of judicious and pertinent comments, it was impossible to draw from his notes the slightest assessment, or conclusion. Vartan was as little concerned about this as he was indifferent to the splendours of Hangchow. In fact his mind constantly strayed back to Peking, and to Jebe.

Vartan stayed there two months. On the day of his departure he was seized with apprehension: what if Kubilai had used his absence to have his friend executed? When he hoisted himself on to his horse, the hundred thousand towers of the Sung city, its twelve thousand bridges, canals and countless sailing vessels, its quaysides where courtisans flaunted themselves, the black ruins of its imperial palace destroyed long ago by fire, its gar-dens, squares and avenues, its artisans who sold hare and deer, partridge, francolins, capons and geese, yellow and white peaches, spices and pears – all these things were already blotted from his memory. His only thought was for Jebe.

In Peking his friend awaited him. But while Vartan paced the wharfs and his pen detailed the riches of Hangchow, Jebe married Toregene.

He did not conceal this second marriage from the Armenian, and was able to forestall any jealousy by arguing that he had taken a wife only to assure his progeny. For the Mongol who does not father sons is little respected. So what would be said of an emperor, since that is what he was to be!

Toregene was fifteen. She was fat, garrulous and mean-spirited. With a high opinion of her own beauty, she walked through the streets with the aim of attracting attention. Though voluptuous and born to be lusted after, she placed fidelity higher than any other virtue. She loved Jebe perhaps as much as Sogotai had loved him.

To her large circle of women friends, she declared that she had the most satisfying man on earth. Yet everything gave the lie to this: he made a habit of staying away from home without explanation, and if by chance she reproached him for it he would bully her or retreat into a stubborn silence that petrified her. Toregene's view of her husband was that he was more mysterious than the darkest night. Being someone who by nature hated mysteries, she tried to find out why he was neglecting her. One day she asked her brother Jamuka, whom she adored, to help her discover the secret of these absences. He gave a vague promise, making her angry at what she sensed was his reluctance to help her. But in the face of his sister's repeated entreaties, he capitulated and agreed to act as her spy. Which he did not do, for Jebe and he were friends, they liked and respected each other. He had also seen something of Vartan, and very quickly gauged the strength of their relationship. A comparison between his sister and the Armenian did not favour the former, he said to himself. Can anyone prefer a frog to a peacock? In truth, Jamuka had always despised Toregene, whom he regarded as foolish. And the stupid girl was not even aware of his feelings towards her. He lied to her: Jebe, he assured her, was

scheming with some courtiers in order to be received back at court. As she loved her brother, she did not doubt what he said.

One April night, ten months after their marriage, Toregene gave birth to a son who was given the name Borok. That night Jebe told Jamuka of his desire to raise an army that would re-establish all the ancient Mongol laws and traditions, and drive out Kubilai, the emperor who had become so outrageously Chinese in his ways. Jamuka approved of this desire for an uncompromising return to the past, and offered to take command of his troops.

The day after this birth, Jebe, without any scheming or petitioning, found himself back in favour with Kubilai. The khan gave him a bowl inlaid with rubies and emeralds, which Jebe accepted, remaining nonetheless wary. Cunning inceases with age, he thought.

In May, Kubilai set out on the traditional journey to Shang-tu. His cavalry escorted him from Peking to his summer palace. Sprawled on a two-wheeled cart drawn by four elephants, his gaze fixed on the horizon, he rode by, indifferent to the villages he passed through, to all those fires lit in doorways in his honour. It was his last journey to the vines and gardens of Shang-tu, to that deep-blue-canopied sky, to a beautiful summer that spangled with gold the rooftops and walls, and the cages in which eagles, gerfalcons, and sakers were confined: the old emperor knew this. The proof was, he was losing his taste for women and boys, and more seriously, fighting, destroying and killing wearied him. And his body was betraying him: his eyesight was failing, his limbs trembled, his heart kept racing. Often he dozed instead of listening to the reports of his ministers, or dispensing justice, or rejoicing in a victory. And worse: he wept for no reason in front of

his ambassadors, soldiers, sons. One day he heard one of his captains express indignation at seeing that the emperor sometimes forgot who he was. This was certainly the last journey he would make. Wives, concubines, progeny born of the imperial seed, sorcerers and monks formed his retinue. Jebe was among them, with Toregene at his side, and their son in her arms.

All the way to Shang-tu she was surly, morose, picking quarrels at the slightest pretext, dwelling on bitter thoughts. The reason was that, shortly before setting out, she had learned, through the indiscretion of one of her cousins, both of Jebe's lover and Jamuka's deceit. At last she understood the coldness of the one and the evasions of the other. And this charitable cousin had relished telling her of the way her husband spoke of her: she was brainless, enamoured of herself, monstrously jealous, ambitious beyond her capabilities – these were the things he said. And that was not all: the future he had in store for her was not a very enviable one. As soon as she had given birth to several sons – it was best to be provident, was it not? – he would repudiate her, or consign her to an inferior role, for he wanted the whole world to recognize as his favourite, his spouse, his best friend, this cunning Armenian, this prostitute monk, this out-and-out schemer. She would never allow it to happen. She, Toregene, would show them what stuff she was made of. Like Jebe, and Jamuka, she loved combat and power. Hatred, truculent vengefulness, cruelty: she would prove capable of defending herself, of destroying the person who dreamed of destroying her.

It was a beautiful summer. But Kubilai did not notice its splendour. He was obsessed with his imminent death and the choice of a successor, preferring the company of sorcerers and astrologists to that of his warriors. Through the vagueness of their predictions, he perceived the darkness coming towards

him. Then he shut himself up in his apartments and prayed to Tengri to give him time to make preparations for the future of his empire.

At the end of August, Kubilai and his court returned to Peking.

# XXXVII

Jebe and Jamuka were very busy that autumn. They organized secret meetings in which they urged discontents to rebel against the regime. Some princes joined them, won over by the idea that it was necessary to uphold the whole corpus of Mongol laws. Conspiring, cursing, constructing plans kept their minds occupied, gave a sense of importance to the young and rejuvenated their elders.

It was a strange period. It seemed as if Peking was no longer the city of spies. The khan's morbid suspicion of his subjects abated. But perhaps this was just an illusion. Whatever the truth of the matter, people acted as if it were so.

Kubilai's health deteriorated at the beginning of December. Korean magicians had been summoned to exorcize him. According to legend, they had the gift of miracles. But Kubilai was to ruin their reputation. Their noisy incantations were powerless to revive his strength. All that survived of him was his scintillating laughter rising above their cries to strike the four walls of his room, its echo still resounding from columns to ceiling long after the Koreans had returned to their homeland.

Kubilai died in February of the year 1294. Jebe was devastated by the news of his death. It deprived him of being able to slay with his own hands a despised sovereign, of being the saviour of the empire. And already the princes who had been his allies were deserting him. The violence of his language, his unbounded ambition, his poor sense of the realities of the situation had shocked them, made them grow wary of a youth who, little by little, they judged to be a hothead, a dreamer, even a madman. The election of Temur Oljeitu brought them together as one man around the new emperor, for already he

was praised for his temperance, the austerity of his behaviour, his faithfulness to the laws of Genghis Khan. But Jebe denied all this. To accept it would have been to give up his desire to rule one day over the world's greatest empire. Refusing to admit defeat, every morning, as one polishes weapons, he sought to preserve the brightness of his illusions, and he managed to persuade Jamuka and a few others that the battle must go on, but not in Peking. It would be best to take refuge for a while in the North, at Karakorum, where Jiruki surely awaited them, where he was no doubt gathering the tribes that had still not succumbed to the lure of Chinese ways, and where finally an army would be assembled with the capacity to make this Temur turn pale with fear.

Three months after the start of the new khan's reign, Jebe and his small troop of fanatics left Peking for Mongolia.

# XXXVIII

So eighteen men and women set off in the certainty that they would control an empire sooner or later. But though the adventure began in high spirits, it proceeded in hardship. For getting to the land of their ancestors is no easy matter. There are arid plains to cross and passes to be negotiated, the Gobi Desert and torrent-like rivers to contend with. There are hunger and thirst that extinguish all hope, and imperial garrisons to be avoided, which means extending their journey. There are horses that baulk at going any further, loaded down with the treasures they have taken with them. There is the fire-like searing wind, and the drenching rain. There are sleepless nights because prowling round the camp are strange beasts, monsters, the wandering gods of primitive peoples decimated long ago. There are days when the silence is terrifying. There is anguish, fear of death, the sense of being utterly insignificant. There are the cries they give for no reason, and there are those moments when they tell themselves that what they are doing is madness. But there is also Vartan persuading them to keep going, and never give up, for nothing is worse than the Pamirs, and yet it is possible to emerge from them alive. There is Jamuka setting an example: pressing on, undeterred, as though he suffers no distress. But above all there is Jebe, relating the birth of Genghis Khan, the hardship that for a long time was his faithful companion, his conviction that he would soon become king of the world, his struggle against scepticism, baseness, cowardice, his belief in his own destiny, his early victories, his friendships and his love affairs, his rapid rise to power, and the establishment at last of his empire. Transfigured by his narrative, Jebe then seems like a survivor and continuer of that heroic age. And they take courage again,

181

hold up their heads once more, and follow this prince who is guiding them to glory.

The last days of spring were upon them when Karakorum came into view. To reach it, they had only to ford the river that flowed round the walls of the town. But though he had so often dreamed of entering it, Jebe wavered. He sensed some danger from the stone battlements and the white yurts standing here and there. The ancient capital seemed like a trap laid by he knew not whom. He then took the decision to circumvent the city and continue eastwards, especially as Jamuka had persuaded him that a man by the name of Buri was waiting for him not far away, and that this man was their ally. At the head of a small army, he too dreamed of restoring the past. So they rode away from the ancient capital of the Mongols. It was only a temporary delay, Jebe tried to reassure himself.

The small band pitched camp on a hillside. That night Jebe did not sleep. Crouched by the fire, with his arms crossed, he stared at the flames in worry. Why this apprehension before Karakorum? Why this vague feeling of failure? Why suddenly this secret fear? And Buri, who was he really? A friend or one of the khan's men? Were they approaching a new era, or heading towards desolation, death? But how could he answer such questions? The wind suddenly freshened. It blew across the plain, swept over the hill, gusted round the animals, woke the sleeping men, squalled and raged and whipped. In this turbulence, the flames guttered, then rose, hissing. They were like a huge flower tearing itself to pieces. In this blaze Jebe saw images overlapping each other, pursuing each other, scattering across Mongolia to every point of the compass. He saw packs of horses, flocks of sheep, forests, lakes. And that was not all. He saw soldiers fighting shield on shield, wounded men and blood, black standards flying and sabres gleaming white in the moonlight. He also saw himself sitting on the khan of khans'

throne. Why then this apprehension and fear? But he could not make up his mind to return to Karakorum. Something told him that this would be tempting fate, courting disaster. And Buri? Was Jamuka to be believed when he said that this tribal chief was a loyal man? Jamuka's instinct rarely failed him. Jebe had had proof of this a hundred times. Well, then, it was decided. They would go and meet this stranger.

At dawn the wind dropped, the fire finally burnt itself out. Jebe turned to Toregene. What madness to have brought her with him! She hated him, her eyes proclaimed it. Jamuka had also confirmed this belief, since he had heard her in Peking, attempting to sow doubt among their companions as they were making preparations to leave. He would lead them to catastrophe if they followed him, she said. But no one had listened to her, for it is well known that women by nature have a perfidious tongue. Toregene had then swallowed her resentment. What would she try next? Impossible to predict.

'Borok has a fever,' she said.

'It's the wind,' Jebe replied.

'Borok has a fever,' she repeated. 'And the cause of it is not the wind, but Vartan, the stranger whom you force on us. He's working against us, I can feel it.'

'It's the wind,' Jebe repeated. 'Just the wind. The wind is dying down, the fever will pass, and one day Borok will succeed me.'

But the fever developed throughout day. In the evening the child had a fit and died. Toregene immured herself in a catatonic silence. So there were neither tears, nor cries, nor lamentations. Turned to stone, she let her husband take her son from her to go and bury him, aided by Vartan. So it was that not far from Karakorum, a tiny mound of freshly turned soil could be discerned: this was to be the sole trace of this child's passage

through this world. Jamuka felt a rush of tenderness: he stroked his sister's hair.

'Don't touch me,' she murmured.

He recoiled, as though terrified by that quaking, wounded, animal voice.

And when Jebe came back to his troop gathered round Toregene, she gave a little dry laugh. 'No son, no empire, nothing,' she hissed.

The men stared at each other. Maybe this woman was right. Later in the darkness they conferred in low voices. Tengri was abandoning Jebe. But the gods never give a reason for their anger, their curses, their ill will. They act. And the child of a prince suddenly dies. The small band was turning their back on Jebe, without yet admitting it to themselves openly. They thought of Buri. This tribal chief possessed large herds of animals, great quantities of weapons, concubines, and above all sons. In the messages he had sent to Jamuka, Buri had specified the extent of his wealth. Was he not evidently meant to be the future master of the steppe, of China, of a whole kingdom? And was it not this that Tengri had clearly intimated in this extraordinary way, by depriving Jebe of an heir?

Jebe's behaviour that night scandalized his warriors. He seemed determined to ignore his wife's grief, and to feel no sorrow himself. After retiring, he availed himself of his favourite as if he had suffered no bereavement. They even heard him laugh, those ripples of laughter that mark festive occasions.

He scandalized them again in the morning, even more profoundly this time. Not having been able to replenish their supplies at Karakoram, they were beginning to run out of food. He announced that it was going to be necessary to hunt. The laws of Genghis Khan forbade it in this season, they protested, for the beasts must be left in peace from spring to autumn in order to reproduce.

'You're going to be the one to break these laws that you've

always said you wanted to uphold? You dare to do this?' cried Jamuka.

'We'll hunt,' the other insisted.

Vartan too tried to reason with him, but only succeeded in exasperating him. Worse still, Jebe scornfully accused him of betrayal.

'I'll hunt alone, then,' Jebe decided, but when he tried to mount his horse, one of his warriors, Eljigidei, prevented him.

'No, you won't.'

Faced with the hostility of the others, bearing down on him, sabre in hand, Jebe finally gave way.

'I shan't forget,' he shouted. 'Tomorrow, or in ten years' time, you'll pay for this.'

# XXXIX

Jamuka noticed the three pools lying in a straight line running eastwards. They indicated, as a messenger had told him in Peking, that they were close to Buri's camp. Beyond the pools, tall pikestaffs, plumed with feathers and stuck in the ground, marked the way.

The last lance was planted at the top of one of the five hills surrounding the plain where Jebe was to meet the man supposedly waiting for him. But only a single white yurt stood on the grass expanse. There was not a single hobbled horse, nor any figure, of man, woman or child, to be seen in front of it. The silence was reminiscent of that over Karakoram. It was the silence that precedes the verdict, that oppresses armies just before their engagement in battle, that surrounds the gods.

Jebe scanned the countryside, and above all that wool tent, which looked as if it had been left behind on the plain, a puzzling and absurd sight. His men crowded behind him, for he looked impressive again, motionless, proud and imperial. In the eyes of his companions he was no longer the madman and renegade that he had been on the day after his son's death. He alone, they thought, could interpret the strange calm of this place.

'An ambush or a joke?' Jebe asked Jamuka, who remained silent.

'Let's turn back,' Eljigidei suggested.

'Never,' retorted Jebe. 'You and Hulegu, go and patrol the other side of these hills, and check there are no warriors assembling.'

As the two horsemen rode off, he turned his attention back to the plain, as though fascinated, as if he could detect the invisible. When the two men came back, they declared they

had seen nothing suspicious. Not a living soul, not even a hare or a wild ass.

'So it's a joke, then?' Jebe said sarcastically. And without waiting for a reply, he galloped down the hill towards the yurt.

He lifted the tent flap, with Vartan and Jamuka at his heels. The only furnishing the tent contained was a carefully rolled-up carpet that gave off a smell of rotting flesh. With great jerks, Jebe unrolled the carpet, which yielded the dead body of Jiruki. He gave a cry that sounded like the scream of a soldier mortally wounded by an arrow, then bowed over the corpse and finally gave way to lamentation. He suddenly knew what it meant to see the darkness at the heart of the day's brightness, he felt an explosion of grief, and knew that it would never leave him. Then he vowed to kill Buri – for who else could have done this deed? – and to put all the world's empires to fire and sword.

A night of vigil, prayer and wind brought together round a feeble fire the entire band of men and their few womenfolk. There was not one tree to feed the fire, and brushwood was in short supply. In his night of anguish, Jebe wanted a conflagration, funeral pyres, the plains set alight; he wanted a blaze the height of a tower; he wanted to spread terror across the whole earth. So at dawn he slashed the yurt to shreds and threw the felt tatters onto the flames. Then, vying with the sun, the fire dispelled the shadows.

The sky was thundering and the sky was a god. It was Jamuka who first saw a frieze of horsemen appear on the ridge of three of the six hills. Jebe recalled his father's advice: if the enemy takes you by surprise and you are inferior in number, the only solution to avoid defeat is to erect a wall of flames between you. This was immediately done. But Tengri was surely not Jebe's ally that day: rain began to fall. Then the

horsemen, with Buri at their head, came streaming down the hillside. Before this army, all Jebe could do was give the order to flee.

The arrows flew in such great number that the sky turned dark. Lightning struck a bush, sowing equal terror among the fugitives and their pursuers. War cries died in men's throats. Arrows were returned to their quivers.

The storm moved away and silence descended. Jebe advanced, towards an army turned to stone, towards its confounded leader. He halted his mount at twenty paces from Buri and eyed him up and down with a look of inextricable fury, pride and insolence. Then he turned, joined his companions, and his troop rode off through the passage between two hills.

They galloped for a long time over muddy ground. Behind them, but at a certain distance, the sound of a thousand hoofs and more was swelled by shouting. It went on like this for several days.

One morning everything fell silent. Yet the chase continued within them. A thousand hoofs and more ploughed through their dreams, arrows whistled, cries rang out. They woke with a start and fear showed in their eyes. Jebe jeered at them, pitied them for their deafness, and bullied them. Often, during the night, he would shake them out of their sleep. Couldn't they hear the ground rumbling, the hordes of horses approaching? Couldn't they hear Buri shouting and his warriors singing? He mainly persecuted Jamuka and Vartan. Jamuka had behaved like a fool, by trusting Buri's protestations of friendship. Vartan had trembled like a woman when the horsemen invaded the plain. Now Jamuka was talking of giving up their crazy escapade, of returning to Peking, of doing penance before the khan. And Vartan was denying that he had promised to bear arms, to become drunk on the smell of blood. For what Jebe had forgotten was this: the stranger is

by nature false, and not to be trusted. Yes, they were fleeing right now, but soon they would join the cohorts of Mongols who had looked forward to their arrival in the North. For years they had been waiting for the supreme master, they were expecting him, Jebe was sure of it. These men were in all his dreams. And Jebe's dreams did not lie.

That said, he turned from Jamuka and the monk to Toregene, whom he accused of indifference to his father's death. Not that this surprised him: she was in the habit of speaking ill of the brave. Drawn to the contemptible, she would no doubt have preferred Buri and his treachery, his sons without honour, his shameless captains. She did not react to these accusations. She seemed very weary, apathetic, almost oblivious.

The troop reached the forest region.

To rest their exhausted horses, repeated halts proved necessary. And meanwhile the men were gnawed by hunger. They staved it off by stuffing themselves with berries and roots. When the hunting season returned, and consequently their strength, then, they thought, they would give Jebe the slip, return across the plains and the Gobi Desert, and head straight back to China.

During these halts, Vartan picked bilberries that he gave to Toregene. He knew that she blamed him for the death of her son, but to see her like this, with hollow cheeks, her eyes closed, a slouching body, he felt some pity for her.

'Consorting with the bitch, my friend?' Jebe said derisively. Once, he fingered Vartan's torso and arms, and concluded his examination with a humiliating and tragic laugh. 'This little monk was born to live in a town, this little monk has a shameless love of women,' he chanted. The Armenian could never defend himself against Jebe, who would always interrupt him. Despite everything, Vartan continued to love this man who vilified him.

★

The women's breasts suddenly became swollen with milk. They squeezed their breasts, moaning. Milk also seeped from hundreds of little sores that formed all over their body. The milk turned sour, the sores went septic, the women weakened and died. Their husbands kept vigil over them, buried them, then disappeared into the forest. Before they left, they apologized to Toregene, who had been spared the disease: she had warned them against her husband, they had ignored her warnings and everything since then had been disappointment, madness and misfortune.

The husbands' flight, as it was referred to afterwards, led to the defection of the others. Nostalgic for the Chinese soil on which he had been born, and consumed with remorse for abandoning his wife, children and concubines for a madman, Eljigidei stole away one morning. His absence, and the lack of his fraternal solicitude towards them, of his vitality, devastated Tolun and Jelme. They wavered for several days before making up their mind to go back the way they had come, to rivers broader than seas, to fields more boundless than the Mongol plains, to the city of the khan. And then it was the turn of Godan the timid, of Sartak the inquisitive, and Orda the generous to mount their horses and vanish into the dawn mists.

Jebe was not sorry to lose them. It was not worth shedding any tears over those ungrateful, fearful cowards. Goodbye and good riddance to them.

Rankled by Jebe's sarcastic remarks, and having lost all hope of a glorious future, Jamuka also wanted to flee, but before doing so he wished to save his sister from this lunatic's grasp. They would go and join the Golden Horde or some distant relatives living in Persia, for he harboured few illusions about the emperor's mercy.

One night Jebe caught him loading his mount, and his

sister's, with a few clothes and provisions – burnet, hazel-nuts, acorns, onions.

'If you leave me, you'll do so without weapons, furs, food supplies, or anything at all,' he said. 'And without Toregene. Are husbands and wives to be separated?' Whereupon, he spitefully cut down their bundles with his sabre, and they split open on the ground. In a fury, Jamuka drew his weapon. They exchanged insults, then crossed swords. Of equal strength, the two men fought for a long time by the light of the only fire. Sometimes they moved away from it. Then darkness enveloped them, and the sound of their breathing and the clash of their weapons were the only indication of a fight taking place. Shortly before dawn the fire went out, mist covering the ground, the trees and these two warriors who seemed to have been battling against each other for an eternity.

When day broke at last, one of them gave a cry and sank to the ground. It was Jamuka. In a stupefied daze Jebe stared at the extended body for a while, then became vaguely aware of the horses stamping, the wind in the leaves, the birds waking, the cold, the light. Everything was as it should be: the world was emerging from darkness again, and victory fell to him who had the soul of an emperor. He smiled. He was more eager than ever to continue northwards, to that land where the shades are true, and the dead are legion, as his father used to say, where a man reigns serene over silent armies, and betrayal, love and suffering no longer prevail. 'So, was that where you wished to go, father?' Jebe murmured. It was then that he heard footsteps. Vartan came up to him. During that night's duel he had forgotten the Armenian. Where he was going, he had no need of a companion. A man goes there alone, Jiruki also said. Before Vartan could say a word, he ordered him, with perhaps some slight emotion, with what was unmistakably a firm kindness, to take weapons, furs, food supplies, and leave him. But he became abrupt, scornful, full of

rage again when his friend begged him not to go. He even struck him across the face. Then as if trying to escape some danger, he ran to his horse, mounted it and galloped off at full tilt.

Vartan had thrown himself in hot pursuit, tried to catch up with him, and failed. So it was that he found himself in a landscape where tall stones stood here and there like steles. He experienced utter loneliness then, inexhaustible tears, in a word, despair. Infinitely weary, he lay down at the foot of one of these providential pillars.

The evening cold was strangely soothing. He ran his finger over the stone, the way one might draw signs in the sand, dreaming of painting, on a big white wall, the monastery at Sguevra and the caravan leaving Sis, his father and Hethum, Montefoschi and Hovsep, the passes through the Pamirs and the desert of Sinjiang, the tree in the square at Kanchow and Kao Hsuan, Kubilai and Jebe, the Gobi and the plains of Mongolia, the death of Jamuka and Toregene abandoned in the forest. He struggled to get his feet: he needed a quiet place, a place where he could create this great work that would gather in a single vision kings and adventurers, sages and fools, angels of heaven, creatures of the night and the splendours of the universe; a whole life would emerge, at once apotheosis and evocation of hell. Suddenly he felt in his heart the same pain as he had experienced once on the terraces of Erzincan. He staggered, then sank slowly to the ground. He closed his eyes, mumbled a few disconnected words – brush, monastery, love – then went into spasms, and died.

# XL

After skirting lakes, fording rivers, passing through forests, Jebe
came to a barren, windswept, icy steppe. Anyone else would
have hesitated to proceed across these lands where the sun
never penetrated an iron-grey sky, where the wind assailed
the body without respite, where the nights seemed as if they
would go on for ever. But Jebe was no longer a man the
darkness could frighten. On the contrary, the sight of this
hostile world exhilarated him, for he knew that he had
entered the Land of Darkness, as Jiruki called it, and it was
here that at last he would become emperor. And even when
his horse collapsed under him, he kept going.

Nothing slowed his frantic progress, neither hunger, nor thirst,
nor the cold. He was indifferent to these hardships. Yet, one
evening, his strength failed him. He dropped to the ground
and immediately lost consciousness. When he awoke, he
found himself in the hut of a man who belonged to the Crow
tribe, one of those that inhabited the Land of Darkness. Word-
lessly, the man made him drink, fed him, covered him with
furs, stoked the peat fire and watched over him through the
night. But the next day the whole clan forced him to drive out
this gaunt and ragged stranger with a mad look in his eye,
because his presence had a peculiar effect on some of them:
their limbs were seized with trembling, as at the approach of
the demons of the tundra.

Jebe encountered other tribes on his way. They did not all
have the same attitude towards him as the Crows. The Tetras
venerated him like a god, the Geese wanted to introduce him
to hunting wild oxen, and the richest man of the Swans
invited him to share his steam bath. He loved Jebe like a son,

and offered him his daughter in marriage. Nothing could deflect him from this idea. The night before the wedding Jebe heard a kind of summons from outside. He immediately came out of his hut and at the edge of the village he discerned shadows, moving across the snow that had fallen several days earlier. They were waiting for him. This was the army of which Jiruki had spoken. It was the largest gathering of horsemen he had ever seen, all Mongol warriors who had died on the field of battle or at the gates of towns in the days of Genghis Khan, thousands of ghosts who had come to meet him in order to accompany him to the furthest reaches of the world. Then he left the sleeping village behind, heading towards the North again, followed by the fabulous horde.

He went on for days and nights. He knew that he had reached the end of his journey when the army of the dead suddenly halted. The Land of Darkness ended here. Beyond lay the ocean. Jebe saw this dark green expanse as a boundless steppe and he remained for a long time gazing at it. Then not far away from him he noticed a block of ice, the sight of which caused him extreme joy. He unsheathed his dagger, and at once began to carve this mass. The blade, like that of legendary swords, did not break. And, no doubt by the will of Tengri, daylight prevailed for as long as Jebe laboured at his task. But the sky suddenly darkened the moment he laid down his knife. What the sculptor had just completed was a throne. When he sat on this seat of ice, the army stood behind him, still, and vigilant.

During the night it snowed. Jebe's head dropped to one side and the snow buried him.

## Contemporary Literature from Dedalus

**The Land of Darkness** – Daniel Arsand £8.99
**When the Whistle Blows** – Jack Allen £8.99
**The Experience of the Night** – Marcel Béalu £8.99
**Music, in a Foreign Language** – Andrew Crumey £7.99
**D'Alembert's Principle** – Andrew Crumey £7.99
**Pfitz** – Andrew Crumey £7.99
**The Acts of the Apostates** – Geoffrey Farrington £6.99
**The Revenants** – Geoffrey Farrington £3.95
**The Man in Flames** – Serge Filippini £10.99
**The Book of Nights** – Sylvie Germain £8.99
**The Book of Tobias** – Sylvie Germain £7.99
**Days of Anger** – Sylvie Germain £8.99
**Infinite Possibilities** – Sylvie Germain £8.99
**The Medusa Child** – Sylvie Germain £8.99
**Night of Amber** – Sylvie Germain £8.99
**The Weeping Woman** – Sylvie Germain £6.99
**The Cat** – Pat Gray £6.99
**The Political Map of the Heart** – Pat Gray £7.99
**False Ambassador** – Christopher Harris £8.99
**Theodore** – Christopher Harris £8.99
**The Black Cauldron** – William Heinesen £8.99
**The Arabian Nightmare** – Robert Irwin £6.99
**Exquisite Corpse** – Robert Irwin £7.99
**The Limits of Vision** – Robert Irwin £5.99
**The Mysteries of Algiers** – Robert Irwin £6.99
**Prayer-Cushions of the Flesh** – Robert Irwin £6.99
**Satan Wants Me** – Robert Irwin £14.99
**The Great Bagarozy** – Helmut Krausser £7.99
**Primordial Soup** – Christine Leunens £7.99
**Confessions of a Flesh-Eater** – David Madsen £7.99
**Memoirs of a Gnostic Dwarf** – David Madsen £8.99

**Portrait of an Englishman in his Chateau** – Mandiargues £7.99

**Enigma** – Rezvani £8.99

**The Architect of Ruins** – Herbert Rosendorfer £8.99

**Letters Back to Ancient China** – Herbert Rosendorfer £9.99

**Stefanie** – Herbert Rosendorfer £7.99

**Zaire** – Harry Smart £8.99

**Bad to the Bone** – James Waddington £7.99

**Eroticon** – Yoryis Yatromanolakis £8.99

**The History of a Vendetta** – Yoryis Yatromanolakis £6.99

**A Report of a Murder** – Yoryis Yatromanolakis £8.99

**The Spiritual Meadow** – Yoryis Yatromanolakis £8.99